CELEBRATIONS *of*
CURIOUS CHARACTERS

CELEBRATIONS *of*
CURIOUS CHARACTERS

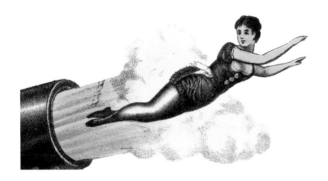

RICKY JAY

❖ ❖ ❖

McSWEENEY'S BOOKS
SAN FRANCISCO

ALSO BY RICKY JAY

Cards As Weapons

Learned Pigs & Fireproof Women

Many Mysteries Unraveled: Conjuring Literature in America 1786-1874

The Magic Magic Book

Jay's Journal of Anomalies

Dice: Deception, Fate & Rotten Luck (with photographs by Rosamond Purcell)

*Extraordinary Exhibitions: The Wonderful Remains of an Enormous Head,
The Whimsiphusicon, & Death to the Savage Unitarians*

Ricky Jay Plays Poker

Magic 1400s-1950s (contributing author)

for Winston Simone

CONTENTS

Vampires Exposed

or

Ferreting Out the Woman Grafters

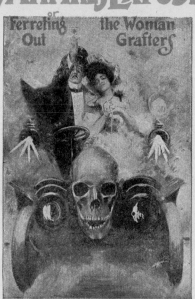

Clifton R. Wooldridge

AMERICA'S SHERLOCK HOLMES

Price 25 cents

INTRODUCTION

MOST EDUCATION AND ALL POLITICS consists in the promulgation of universally acknowledged truths.

But the truly educated man, for my money, is he who knows something that I not only do not know, but the existence of the category of which was to me unimaginable prior to its revelation.

Such categories, for me, include the bar bet: e.g., I'll bet you I can take this thumbtack and, while remaining seated on this stool, stick it in the ceiling; and quantum mechanics. Somebody said that any scientific theory or construction sufficiently removed from common comprehensibility is indistinguishable from magic. One of my age (myself) comes across this every day, in the ease with which the young (everyone else) deals with computers.

"But," I say or think, "I don't understand," and see, in the demeanor of those around me, the epithet "fogey."

But, finally, and in my defense, it is not that they do understand, but that they don't care: they are not going to potentially take the toaster out to the garage to fix the heating element; their tools have progressed beyond general human comprehensibility and, so, are indistinguishable from magic. Ingrid Bergman, in *For Whom the Bell Tolls*, asked of Gary Cooper, "Where do the noses go?"

I ask the same thing of the molecules, or whatever they are, that fly around in something the young are content to name "the ether" and accept that it can tell you, if asked correctly, the weather in Spain, or the name of the ref in the first Dempsey-Tunney fight.

Mr. Jay teaches that the more intelligent a person is the easier it is to fool him; for we all believe in magic. We sometimes call it Love, or the New Economy, or the Nigerian Chain Letter, or wrinkle cream; but who would like to live without his favorite flavor of suspension of cause-and-effect? Not you and not I.

We want to be delighted, we want to believe, and then we want to know how the trick was done. For a magician to accomplish the third without diminishing our enjoyment in the prior two is an excellent trick indeed—here accomplished by Mr. Jay.

—*David Mamet*

*Some time ago I was asked to present a weekly four-minute essay
on KCRW, the National Public Radio station in Los Angeles.
This I did with great pleasure for a year. The result,
embellished with a visual catalyst to my verbal peregrinations,
is published for the first time in these pages.*

CELEBRATIONS *of* CURIOUS CHARACTERS

MYNAH

IN THESE HEADY DAYS of pet psychics and talented tool-wielding New Caledonian crows, I feel compelled to relate the story of a bird much heralded in the annals of paranormal activity. I must confess at the outset that I am not known for my ornithological acumen, and to demonstrate this unequivocally I offer an embarrassing episode from my college days.

I was visiting the home of Ruth Christman Gannett in Cornwall, Connecticut, in the company of her granddaughter, my friend Peggy. Mrs. Gannett was a famous illustrator, and her late husband was the book reviewer for the *New York Herald Tribune*, Lewis Gannett. To my great delight the house was lined with books from wall to wall and floor to ceiling. I saw splendid copies of Hemingway, Steinbeck, Faulkner, and many other literary luminaries, often personally inscribed. I was still swooning over the collection when I was dragged from the library to the sprawling garden, where a group of guests had assembled. In the throng, I was told, were a number of eminent bird-watchers. I sipped my lemonade and, like any good sport trying to impress the grandmother of his companion, tried my best to feign interest.

I was startled when an exotic bird flew over my head and I cried with some enthusiasm, "What was that?"

Peggy broke the uncomfortable silence.

"That," she said, "was a robin."

She then found it prudent to address the party.

"Ricky," she noted, "is from Brooklyn."

◆

Another Brooklyn boy, Joseph Rinn, became one of the first dedicated investigators of psychic phenomena. Growing up with Harry Houdini, he became interested in magic and the occult, and as a successful produce broker he offered large cash awards for demonstrations of otherworldly phenomena that he could not explain.

Intrigued by tales he heard of a remarkable bird, in 1899 he visited its owner, Emma Thursby, the famous opera singer. He was introduced to a mynah bird that Thursby had named Mynah. Nothing else Rinn was to witness that day, however, was so obvious. Rinn addressed Mynah, who answered his questions so earnestly and so adroitly that Rinn felt he was actually conversing with the bird. He began to squirm uncomfortably and looked around the room for a concealed ventriloquist. Thursby laughed. Disavowing duplicity and touting the bird's surprising skills, she invited Rinn to address Mynah in the language of his choice. He spoke to the bird in French and received a perfect answer in that tongue.

This exhausted Mr. Rinn's linguistic capabilities — not, however, the bird's, as Mynah nattered on in German, Malay, and Chinese.

Mrs. Thursby asked the bird to play the banjo and Mynah vocally duplicated the complex instrumental solo to "Swanee River." "Would you like to hear Mynah play the piano?" she continued. "No, no," Rinn begged off, "I'm satisfied by his work on the banjo."

"No," Mrs. Thursby replied, "he really plays the piano." Mynah then hopped on the keyboard and with his feet plunked out the notes to "Home Sweet Home."

Rinn grew concerned that Spiritualists would exploit the creature to prove that departed human souls could occupy animal form. When the bird died he was the subject of numerous obituaries and an autopsy that generated much interest. The examining scientists, Dr. H. Holbrook Curtis the throat specialist and Dr. Frank Miller of the Royal Veterinary College of Berlin, were amazed by the flexibility of Mynah's larynx, the strength of his heart, and the remarkable amount of gray matter in his brain. They pronounced him the most astonishing biped they had ever encountered.

AMERICA'S SHERLOCK HOLMES

IT IS NOT WELL KNOWN that the quintessentially British detective, Sherlock Holmes, had an American counterpart. Unlike Sir Arthur Conan Doyle's fictional character, our own Clifton R. Wooldridge, a Chicago detective, was bred of flesh and bone.

With Yankee audacity, Wooldridge dubbed himself "America's Sherlock Holmes," a phrase that appears on the title page of a number of his books.

In the earliest of these, *Hands Up! In the World of Crime*, published in 1901, Wooldridge is rather modestly described as "twelve years a detective on the Chicago police force." His curriculum vitae is embellished, however, with this tally of his credits: 17,000 arrests, 125 criminals sent to the penitentiary, $75,000 worth of lost and stolen property recovered, and 75 girls rescued from lives of shame.

He colorfully chronicles the stiffest sentence ever handed to a bicycle thief, the thwarted attempt of youngsters to corner the Chicago chewing gum market, and the arrest of a woman brazenly seen smoking a cigarette on Wabash Avenue.

Needless to say, it was America's Sherlock Holmes who was responsible for bringing these malefactors to justice.

The Grafters of America was published in 1906. Here Wooldridge's expertise in what we might call bunko or confidence games was revealed as he lashed out against the evils of fortune-tellers, bucket-shop operators, quack doctors, dishonest gamblers, and devious insurance salesmen.

In *The Devil and the Grafter*, Wooldridge appears in full-length photographs in various disguises. He is shown as Heck Houston, cattle baron from Wyoming; a gambler called Policy Sam Johnson; a Jew from the ghetto; and one of society's elite. To my somewhat skeptical, albeit untrained eye, the only distinguishing characteristics of these undercover identities is the length and style of facial hair. Heck Houston sports a long white beard, the ghetto Jew sports a long black beard.

My favorite Wooldridge work is a slim volume with a grand title: *Vampires Exposed or Ferreting Out the Women Grafters*. This pamphlet introduces our intrepid author as "America's Sherlock Holmes, a Real Detective who deals with Real Criminals."

Wooldridge attacks con women he calls "charity chiselers," heartless vixens such as Rachel Gorman, who would masquerade as a nun to solicit donations that she never handed over to the church.

He is particularly unforgiving in his characterization of Miss Jessie Sherbondy, who ran the fraudulent Sunnyside Society—supposedly to aid the children of Chicago tenements. Sherbondy published a newspaper featuring photographs of angelic children she claimed had been rescued by generous donations to her society. Her pleading prose, said Wooldridge, "was enough to bring tears to the eyes of an iron lawn-dog."

In his analysis of these scams, Wooldridge expertly deflates the con artist's adage that you can swindle only someone who has larceny in his heart.

I think I am most fond, however, of the detective's insight as a criminologist. In a passage on rehabilitating felons, he cited a survey conducted at a New York jail.

Of the 599 prisoners surveyed, 34, he says, could barely read, 214 could barely write a letter, 211 were reasonably well educated, 49 had attended high schools and colleges, one was a college graduate, and 51, Wooldridge definitively announced, "Knew—absolutely nothing."

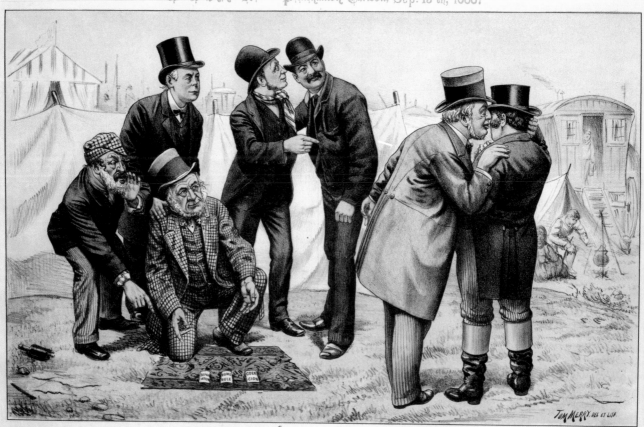

DONCASTER 1888:—"THE SCUM OF THE COURSE;"
OR
The old Sharper and his "Bonnets"

TOSSING THE BROADS

THREE CARD MONTE is not a game of chance. Three card monte is not a game of skill. Three card monte is not a game.

I state this unequivocally, bravely butting heads with unsuspecting marks, distinguished lexicographers, and more than one sitting judge.

Perhaps the greatest swindle of the monte-throwing, broad-tossing, double-dealing ranks has been to persuade players and magistrates alike that one of the most nefarious cheating schemes ever hatched is a mere game.

In 1873, three card monte throwers were called "the worst pariahs who prey upon society under the cloak of gambling." An earlier version of this hustle may have been the first cheating scam ever recorded with playing cards, in 1408. My admiration for the creators and perpetrators of this classic confidence dodge notwithstanding, I shall explain why three card monte is not a game.

The *Oxford English Dictionary* defines a game as "a diversion of the nature of a contest, played according to rules, and displaying in the result the superiority either in skill, strength, or good fortune of the winner or winners." Three card monte is not a game because the player cannot make use of skill or good fortune. He cannot win.

He is not even wagering against just one opponent. The fellow who throws the cards—the operator, the dealer or broad-tosser, as he may be called—has accomplices, and often plenty of them. Three cards, two identical black cards and a queen of hearts, are tossed from the dealer's hand and shuffled onto a playing surface that may be a cardboard box, table, umbrella, or the sidewalk. The player is asked to find the queen. If he is successful, if he chooses the correct card, he will double his wager.

If the sucker, by acumen or pure luck, should happen to select the queen, then a confederate or shill will bet a larger sum on the wrong card, and the operator will take the larger bet. Note this well. Even when the sucker chooses the correct card he cannot win. Usually this serves only to increase the appetite of the fish so that he will bet faster and bet more on the next throw. The monte tosser will be only too happy to accept the sucker's bet when he has staked his money on a losing card.

But wait—I exclaim, as if I were hawking knives in an infomercial—there's more.

The scenario I have described disqualifies three card monte as a game, but what follows shows that it is irrefutably a con. During the course of play the dealer drops a card to the ground. As he bends down to retrieve it, one of the crowd picks up the queen and bends a corner, thereby marking the card. That fellow winks at the sucker and invites him into the play.

When the dealer next throws the cards, the man who has marked the queen wins a large bet by identifying it correctly. On the following toss the sucker, seeing a sure thing, wagers his money on the bent card.

Get this: the spectator, the coney, the gull, the pigeon, the bates, is trying to cheat the cheater. When the card with the bent corner is turned over, it is not the queen but one of the black cards. The sucker, defeated by his own cupidity, has been swindled.

The fellow who bent the card is of course in cahoots with the dealer, who by a beautiful bit of sleight of hand is able not only to take the bend out of the queen but also to put an identical bend into a black card—in full view of the spectators, in the split second it takes to throw the cards from his hand onto the table.

◆

Three card monte is not a game of chance. Three card monte is not a game of skill. Three card monte is not a game.

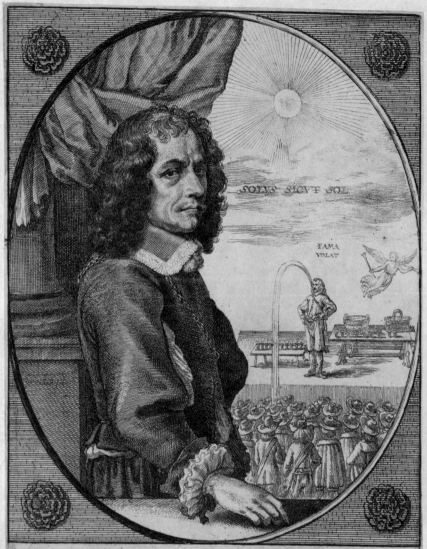

SOLVS SICVT SOL

FAMA VOLAT

VERA EFFIGIES. Dñi. BLASII DE MANFRE NETINI SICULI. Ætat: 72, 1671

Seu ueterum. similis, non conscia sæcula facti,
Seu tua, te, ratio credere tunta uetet,
Visa. tamen mea gesta probant, cum Cæsare Reges,
Miriãdumq oculi, quos stupor attonuit,
Ille ego purarum. grandis potator aquarum,
Qui prius undiferis, uina refundo cadis,
Et quæcunq tibi seu rubra, aut candida poscas,
Vtrinq de largo gutture dona, paro,

Quin etiam, si præ reliquis optaris adustum
Id tibi, de sumpto gurgite munus erit,
Lac, oleum, lupuli potum, florumq liquores,
Insuper angelici poscar odoris opas,
Omnia miriparo salientia gutture promo,
Ac demum altiuolam, iacto potenter aquam,
Ambigis? ause ueni, uolo sint tua lumina testes,
Vnde queas largo credere dona Dei,

TIME

SPEAKING TO YOU EACH WEEK—and you are my new best friend—has made me very conscious of time.

Each day now I jot down phrases and anecdotes to share with you, but I have become acutely aware of how little time we have together. Barely four minutes per week.

How do we deal with—oh so painfully finite—time?

Not long ago I realized that the major challenge in my life had shifted from "How do I pay the rent?" to "How do I have the time?"

Four minutes per week forces one to be terse, not an attribute usually associated with me—or with my writing.

So I am thinking about how and why we measure time—but within the parameters of my own peculiar interests.

I have long been fascinated by water spouting, the ingesting and regurgitating of large quantities of liquid, performed in entertaining fashion.

The golden age of water spouting, as everyone knows, was the seventeenth century. There are records of spouters who preceded that vogue, and there are spouters who still appear on variety shows, but for some reason unknown to me the audiences of the sixteen hundreds were particularly inclined to enjoy such spectacle.

Blaise de Manfre, Florand Marchand, and Filippo Giuliani were all accomplished practitioners of that era, but I am particularly drawn to a Frenchman named Jean Royer. He swallowed large quantities of clear water and then spouted the liquid, in a series of long, graceful, magically changing, multicolored, and perfumed arcs.

But what out-did his rivals was a measure of time. Royer was known to spout a continuous stream of liquid for the entire length of time it took a spectator to recite the fifty-first psalm.

How long, do you imagine, did it take the calligrapher Matthew Buchinger to letter his micrographic rendering of that same fifty-first psalm in a splendid eighteenth-century chancery cursive style? You should amend your estimate to reflect that Buchinger had no arms. He held his quill delicately balanced between his two unarticulated flipper-like extremities each time he painstakingly set his pen to paper.

How long does it take a competent juggler to learn to spin a coin along the inside wall of a bowl? Ron Graham, the former head of math at Bell Labs, accurately estimated the four hours it took me to learn this stunt. And he frequently gives uncannily apt estimates for acquiring other physical skills. One is tempted to ask, "How do he know?" I should mention that in addition to his academic accomplishments, Ron is a juggler capable of neatly keeping seven balls aloft.

A new deck of cards comes in sequence. How long will it take a sleight-of-hand expert to shuffle that deck of cards back into precisely the same order? Our mutual friend, the statistician Persi Diaconis, has given much thought to the problem, and he shuffles cards as well as anyone I've ever seen. As kids we practiced to do the eight perfect shuffles required to complete this stunt in less than one minute.

Young students of magic often try to develop great speed in completing card moves called "sleights." One such complex maneuver, "the pass," is used to secretly transpose the lower half of the deck to the top without that action being seen or even suspected by the audience. But as novices gain more understanding of their art, and become more subtle in their use of time, their emphasis may change.

Here's the old saw. Tyro: "I can do the pass forty-two times in a minute—how many can you do?"

Seasoned Practitioner: "I can do one, but you can't see it."

THE ART OF FAKING
EXHIBITION POULTRY

GEORGE R. SCOTT

CHICKENS

PEOPLE I LIKE—LIKE CHICKENS. I find this very surprising. The screenwriter Janus Cercone nurtures a few of them (treating them to a recreational dip in the hot tub and an après swim shampoo and blow-dry) in her Malibu backyard. She phones to report on their progress. When I come by she holds them out to me, I suppose to see me flinch as if she were proffering a pet python.

William Grimes, a *New York Times* writer and critic, had a number of visits from a black chicken in his Queens, New York, home and wrote a series of articles and subsequently a wonderful book about the encounters.

A few weeks ago the filmmaker Errol Morris dropped by my place. Noticing an illustration of a hen, he began to speak, or rather discourse, on chickens with such passion that I—and considering my primary profession, do not take this lightly—was amazed.

I am a big-city boy, but so then is the cosmopolitan crew just described. Sure, in an attempt to show impartiality in my researches into unusual entertainment I have wielded my pen in praise of performing poultry: a bit on the eighteenth-century showman James Bisset's dancing turkeys; the tic-tac-toe-playing rooster in New York's Chinatown; and even the occasional learned goose. But my knowledge of deception in the chicken world is based entirely on a volume that occupies a place of prominence in my archives on swindling. Published in London in 1934, it is titled *The Art of Faking Exhibition Poultry*.

I like everything about *The Art of Faking Exhibition Poultry*. I like the unsophisticated image of a rooster stamped in black on its deep red cloth; I like the subtitle: "An Examination of the Faker's Methods and Processes; With Some Observations on Their Detection." George R. Scott is the author. I like his credits as they appear on the title page: Honorable Secretary and Club Judge to the Rhode Island Red Bantam Club and the British Jersey White Giant Club; Director of Husbandry to the Gary, Indiana, Public Schools; one-time Judge to the Magpie Duck Club; author of *Modern Poultry Keeping*, *Poultry Trade Secrets*, and *The Truth About Poultry*.

I especially like his dedication, which reads: "To All Poultry Judges and Exhibitors in the Interests of the Poultry Fancy."

Mr. Scott excoriates those dastardly con men who would alter, for their gain and glory, otherwise unsullied poultry. He lists a multitude of scams to improve chicken plumes. One may distort their color with an application of permanganate of potash, analine dyes, or more subtle pyrogallic acids.

We are familiar with chefs adding spice to enhance the taste of chicken, but corrupt poultry impresarios have less conventionally applied turmeric to touch up the feathers on certain females and have mixed saffron in oil to pigment the ungainly pale appendages of certain yellow-legged chickens. Women's rouge has been unscrupulously dabbed on rooster lobes formerly too pallid to pass muster.

The cockscomb may be modified to rid it of various protrusions known as "side-sprigs," and defects such as "duck's foot" and "wry tail" have been surgically corrected to allow the altered chickens to garner awards.

Even though I am a self-confessed tyro in the poultry fancy, I have been swept up by the rhetoric of the impassioned author. We mutually abhor, and I quote: "the appearance of the pseudo-scientific Hogan cult and all its blowsy jargon, its crapulous fundament of snide anatomy, its noisy and prolific drool of whim wham."

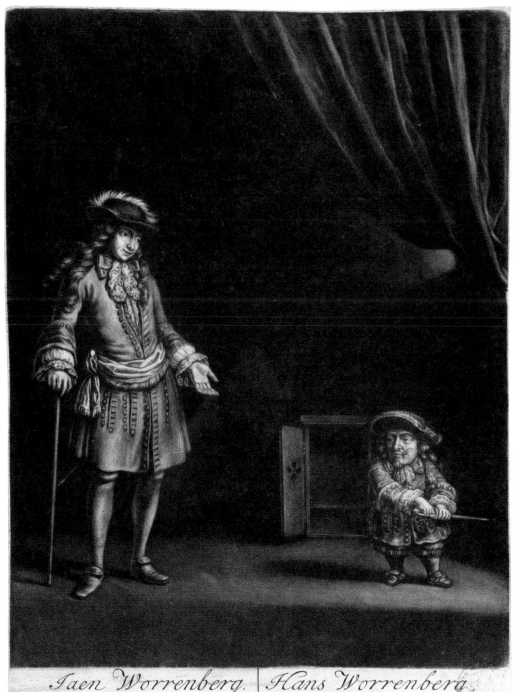

Jaen Worrenberg.
neé en Suisse, ageé de 37 ant. a 2 pied 9 pouce de hoteur.

Hans Worrenberg
Het Switsertie, is Lang 2 voet, en 9 duym.
De Lespine Cum privil: Ord: Holl: et Westfr: fe

CONTRAST AND COMPARE

MINE IS A PARTICULAR MISANTHROPY. I like little people. I like big people. I like conjoined people. I like attenuated people. I just have a lot of trouble with people.

Among the many foci of my acquisitive mania for unusual entertainment are longitudinally exceptional folk—depictions of giants, dwarves, and midgets. Some of my current favorites show giants towering above doorway lintels. These transom-topping images have led me to puzzle over the question of how we measure size. How do we represent the magnitude of these figures—except relatively?

As a consequence, giants and little people often appear in each other's company. For example, at the court of Charles I of England, the giant William Evans produced the midget Jeffery Hudson from his pocket while dancing an anti-masque.

A similar tale is told of the eighteenth-century Irish giant Patrick Cotter, who revealed the celebrated Polish dwarf Count Joseph Boruwlaski from the folds of his copious garment.

In illustrations of such figures the juxtaposition of large and small is not only graphically appealing, it is also a well-considered strategy in the exhibition of the anomalous. It makes the giant seem larger and the dwarf seem smaller, an essential goal in getting spectators to part with real coin.

Little folk are also often shown in the proximity of normal-sized folk for contrast. Sometimes they are presented on chairs or tables to provide a frame of reference—one easily distorted, of course.

Giants are often featured extending their arms out to the side, and people of average height are arrayed below the ninety-degree angle between torso and appendage.

In one oddly prurient engraving from the mid-eighteenth century, a giant billed as "The Modern Collossus" is shown in the company of four normal-sized women. One stands on a table to embrace him. Another cowers away, saying, "Oh, the huge beast he should not touch me for the world," but her companion adds, "But he should me if he was ten times as big again."

The most surprising response—this is 1751, I remind you—is from the woman who stands beneath the giant at waist level and proclaims, "Well, my head will just reach the height of my wishes." The giant modestly responds, "Ladies, if I was Hercules I'd oblige you all as he did the daughters of the King."

My favorite comparative image is of the giant Hansen presenting his diminutive companion, Hans Worrenberg. Hansen gestures with open palm as if proffering his friend to us. While little is known about the giant, Worrenberg was likely the most famous dwarf of the seventeenth century.

He was lauded for his elegant attire. His right eye had been blinded by an early accident while he was spinning flax, but he stands securely on strong legs with both his hands on the hilt of a sword. Behind him is pictured the rectangular box that was his traveling home, a clever conveyance that unfortunately caused his demise. When his bearer fell into the river while boarding a ship, Worrenberg was trapped in the box and drowned.

The juxtaposition of large and small is the most obvious convention in the representation of exceptional size, and it transcends the evolution of visual media.

In a television commercial for Apple computers, Verne Troyer, best known as the diminutive Mini-Me in the Austin Powers films, and Yao Ming, best known as the tallest player in the National Basketball Association, are seated on a plane. Mr. Troyer reaches for his giant-screen laptop computer, while Mr. Yao grabs the smallest and lightest model. Each casts an amused glance at the other, and we at them.

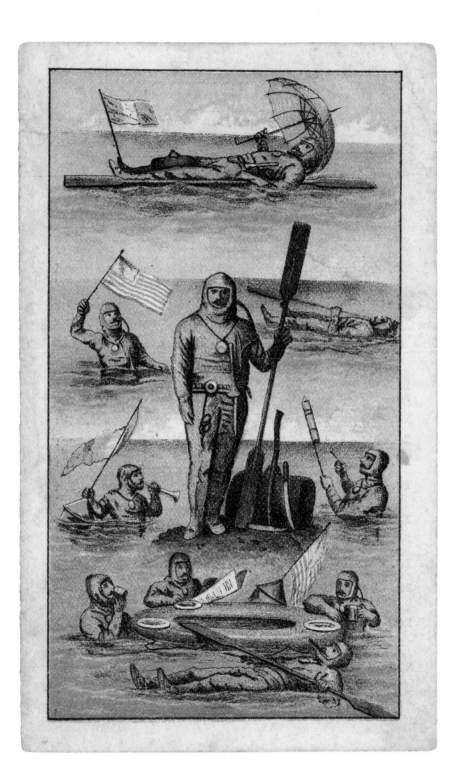

RUBBER SUIT

ROSAMOND PURCELL, THE PHOTOGRAPHER with whom I collaborated on the book *Dice: Deception, Fate & Rotten Luck*, was represented in a wonderful exhibition entitled "Two Rooms" at the Santa Monica Museum of Art.

To say that she is a photographer is wildly understated. Her studio, which consists of found objects in various states of decay, was artistically installed in the museum. Discarded by others, Purcell's objects became a feast for the eyes. In their rebirth they managed to show us much about how and what we see, and why we have become a country of collectors.

Another chamber focused on what was collected in the seventeenth century. It featured the re-creation of the Cabinet of Curiosities of the Danish doctor, naturalist, and antiquary Ole Worm. Working from his published catalog, Purcell reconstructed the contents, a fascinating repository of skulls, spears, and shells that Worm used as a teaching tool.

Among the diverse curios is a hooded rain garment, supposedly used by sailors while paddling simple kayaks. This jacket, constructed of seal viscera, offered qualities of buoyancy and water-proofing. The modern version made for Purcell's exhibition was fashioned from seal intestines, once given to her as a gift when she was traveling in Alaska. They are now shaped and stitched, a painstaking task that could only be accomplished while the skins were damp.

As I contemplated this masterpiece of nautical couture, I thought of Paul Boyton.

Two hundred and twenty-five years after Ole Worm's raingear was fashioned, a Dublin-born resident of Pittsburg, Capt. Paul Boyton, became the first person to swim the English Channel. He is accorded the dreaded asterisk in the record books, however, because he donned a rubber suit and wielded a canoe paddle on his journey.

His garment, which was hooded like the jacket in Worm's cabinet, was constructed from India rubber. It covered Boyton from head to foot, with the exception of an oval opening for his face. It contained five inflatable airtight compartments, one to cushion his head, and had storage for the chattel he considered essential for his journey: a small ax, a flask of brandy, and a foghorn. In an auspicious wind, he hoisted a sail from the sole of his shoe. Despite these accoutrements, Capt. Boyton was the conqueror of the Channel, and he became a major nineteenth-century celebrity.

He was a shameless self-promoter, and his reputation grew so boundlessly that he traveled the world to demonstrate his skills. He was lauded on the Thames, the Seine, the Rhine, the Tiber, and the Danube. In America he navigated the Hudson, the Mississippi, and the Ohio.

He claimed to be a mercenary in South America and was regarded as the heroic rescuer of numerous people. Although Boyton took credit for the invention of his rubber suit, early accounts attribute it to a Mr. C. S. Merriman.

In 1887 the master publicist P. T. Barnum engaged Boyton to demonstrate survival techniques at a "princely salary." At considerable expense Barnum constructed an artificial lake underneath his circus big top for his so-called "Knight Errant of the Deep."

Boyton also produced his own aquatic spectacles. "Paul Boyton's Water Chutes," sometimes called the first modern amusement park, opened in Chicago in 1896. He was one of the promoters of "The Pike," the revolutionary mile-long entertainment midway at the 1904 St. Louis World's Fair, and he played a role in creating Luna Park at the nascent Coney Island in 1895. If Boyton's autobiography were re-released today, he might have an entirely new fan base. His memoir was titled *Roughing It in Rubber*.

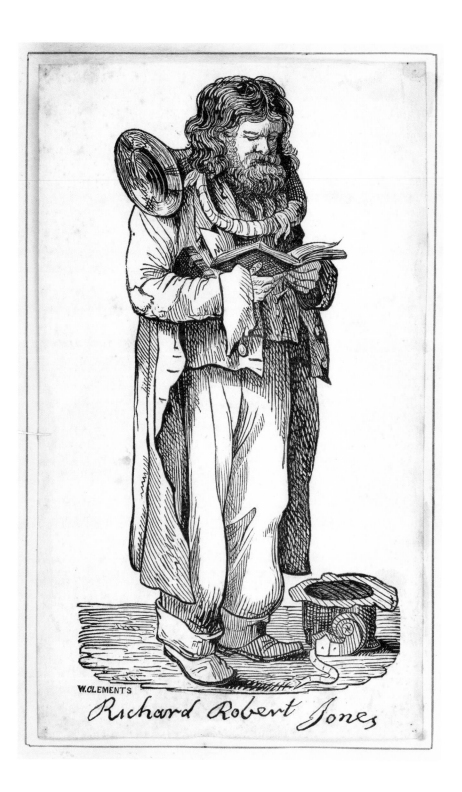

W.CLEMENTS

Richard Robert Jones

THE CAMBRIAN LINGUIST

SOME YEARS AGO I PORTRAYED an Israeli Mossad agent in the film *Homicide*, and the director, David Mamet, asked me to speak a few lines in Hebrew. I studied assiduously and proudly played my part. The movie later screened at the Jerusalem Film Festival, and I asked David about the audience reaction to my part of the dialogue. "Oh they loved it," he said. "They all wanted to know what language you were speaking."

I am terrible at foreign languages. I am filled with admiration for people who excel at them.

The polyglot Richard Roberts Jones, born in Wales in 1780, was the son of a poor carpenter. Although otherwise uneducated, he managed to learn to read the Bible at the age of nine, and began studying Latin at age fifteen. His eyesight was weak, his voice cacophonous, and his personal grooming conspicuous for all the wrong reasons.

But his facility for languages was equaled only by his appetite for them. He was always seen with a book in his hand. His father was not sympathetic to his studies, and he beat Richard for his pursuits until the boy was forced to leave home.

With his shaggy mane of black hair and bushy black beard, he was likened to one of Rembrandt's beggars. At times in his peripatetic career he was helped by sympathetic souls who offered modest employment or handouts. Jones was reluctant to accept charity but seemed unable to hold even the most menial job. He once accepted a position as a sawyer, but he soon collapsed on the ground while cutting logs: he had moved only his arms forward while sawing, unaware that he should also adjust his feet.

Jones had a wild look as he wandered from place to place. His tattered clothing was full of books stowed carefully in all the folds and pockets, and it was said that he could produce specific titles on demand. He was described as a human library.

A similar genius for classification was shown by a twentieth-century vaudeville performer named Arthur Lloyd. At the peak of his powers, he reputedly stashed more than fifteen thousand items in the many cavities of his wardrobe. He claimed to be able to produce any item printed on paper, as requested by his theater audience. He proffered membership cards to the Ostrich Breeders Association or the Communist Party, passes to the White House and tickets to heavyweight championship fights.

Perhaps bored by the ease with which he could acquire languages, Richard Roberts Jones eventually became an itinerant musician, wandering the streets with a French horn draped around his neck. His gift for music was apparently less impressive than his talent for tongues. According to a short biography published in 1822, "by constant assiduity [he] qualified himself to play a few tunes in a manner more memorable for its noise than its accuracy."

Jones wandered the British Isles until age sixty-three, all the while acquiring new languages. Most accounts list fifteen in his repertoire, although one volume that dubs him "the Celebrated Cambrian Linguist" claims he was proficient in thirty-five. In addition to the more obvious options, these included Coptic, Syrio-Chaldee, and Ethiopian.

More singular than his academic attainments, however, were their limitations, for Jones may have suffered from "savant syndrome," the medical term that describes individuals capable of remarkable prowess in one area to the exclusion of almost all other learning.

When questioned, for instance, by an Oxford professor about Andromache, Hector's wife in the *Iliad*, Jones was able, on the basis of the Greek roots, to determine that her name meant "a fight of men," but was unable to offer any insight about her character. Sadly, he was also unaware of Homer's magnificent poetry.

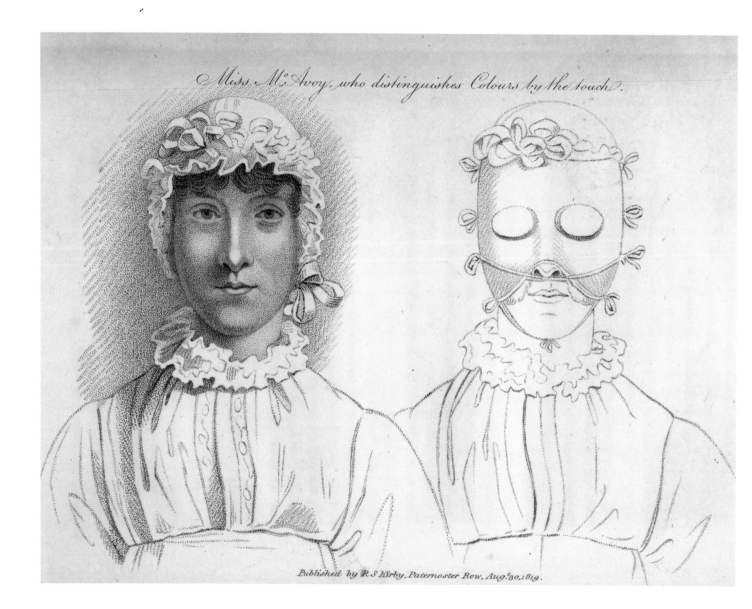

Miss M^c Avoy, who distinguishes Colours by the touch.

Published by R S Kirby, Paternoster Row, Aug.ᵗ 30, 1819.

BLIND FAITH

Seeing, we are told, is believing. This is the story of two women whose specialty was getting others to believe that they could not see. There is no evidence that Catherine Mewis and Margaret M'Avoy knew each other, but at almost the same time these two English girls created sensations by their unconventional approaches to vision.

Mewis was born in Staffordshire in 1802. As a small child she contracted scarlet fever and began to lose her sight. Eventually it was determined that she could see but one day a week. Remarkably, it was always the same day. In 1810 she was the subject of a monograph entitled *A Faithful Account of Catherine Mewis…*[who] *continues to be deprived of her eyesight six days out of seven and can only see on the Sabbath-day.* Four doctors examined the child, but they contributed no testimony to the volume. Because of what her parents described as sensitivity to light, they kept Catherine's eyes bandaged every day but Sunday.

It must be confessed that the supervision of the youngster left much to be desired. She was not placed under scientific observation, and the author was unwilling even to question her hard-working, apparently respectable parents for fear of offending them. How, he pondered, could they suffer their child to endure a blindfold six days a week just to succeed with an imposture or to make money. How, indeed?

Margaret M'Avoy was born in Liverpool in the year 1800. She was a sickly child not given much chance to survive. She too contracted scarlet fever and lost much of her vision. As her eyes lost their acuity, she claimed she could see with her fingers. While blindfolded with a shawl she was able to discern colors and read words by passing her digits over them. She later requested that "gogglers" be put over her eyes, a nineteenth-century form of goggles that protected against wind and dust on an open carriage ride. For Margaret, they were specially fitted with opaque pasteboard lined with paper and fastened down so that no aperture was visible. While wearing them Margaret was still able to "read with her fingers."

Margaret's chronicler also looked the other way: "There does not appear to be any adequate motive for practicing a delusion upon the public," he said. "Her situation in life is reasonable and her mother disavows any intention of ever exhibiting her daughter as a means of pecuniary remuneration." The writer was clever enough to realize that the most appropriate test was to ask Margaret to read in a totally darkened room but he too succumbed to tact, fearing "it might not be very courteous…to make any proposal which seemed to imply suspicion that she was an imposter."

Margaret's credulous fans were treated to new tests, and ever greater impediments to her vision. She was able to tell tactile time from a pocketwatch with a closed case. To block out all light, the whites of hard-boiled eggs or even gold leaf could be applied to her eyelids. If these seem more like the tactics of a modern stage performer working on their repertoire than the struggles of a sightless child, it may be said that Margaret M'Avoy literally pioneered a branch of magical entertainment that became known as "eyeless vision."

In the ensuing two hundred years, many practitioners have been blindfolded, some apparently under far more stringent conditions than M'Avoy could have imagined, and yet they have been able to shoot rifles, ride bicycles, drive cars, and pilot ships and planes.

My favorite exponent of the act, however, was transplanted from Tinseltown to Indiana for this appearance in the 1950s: *"Lovely Miss Arden of Hollywood will drive a new tractor over the streets of Remington while she is completely blindfolded. Tractor courtesy of Holderly Implement Company."*

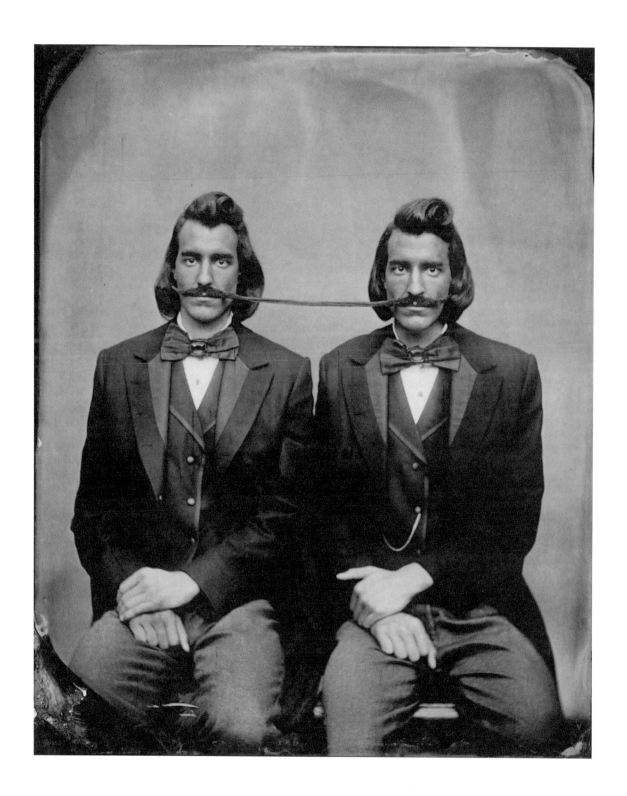

TWINS

OXYMORONIC SIAMESE TWINS ABOUND. We are inclined to think of such anomalies as scarce, but an exotic roster of these pairs have attained celebrity—there have been Spanish Siamese twins, Scottish Siamese twins, and Bohemian Siamese twins (the last representing a geographical rather than a social distinction). If that's not confusing enough, Chang and Eng, the original Siamese twins, were born in 1811 to Chinese parents in Thailand, where they were known as "The Chinese Twins."

In an unaccustomed lapse into topicality, I am prompted to address this subject because of Ahmed and Mohamed Ibrahim, known as the Egyptian Siamese Twins. They were surgically separated in Dallas and are still doing well.

Texas was also the home of Daisy and Violet Hilton, billed as "San Antonio's Saxophone Playing Siamese Twins," perhaps the most famous conjoined sisters of the last century.

They were actually English Siamese twins, born in Brighton in 1908. The pair were among the few sideshow attractions that crossed over to the loftier worlds of variety and cinema. The Hiltons played the famous Orpheum vaudeville circuit, appeared in Todd Browning's classic film *Freaks*, and were the stars of *Chained for Life*, a fictional tale of the tribulations of Siamese twin girls trying to make their way in the sordid world of show business. Movies don't get much worse than *Chained for Life*.

A few years ago, I ran into Whitey Roberts, then a nonagenarian rope-skipping sand-dancing juggler who performed his act in *Chained for Life*. At Canter's delicatessen in Los Angeles he was downing a surprisingly robust meal for a man of his age. After barely recalling me (it had been a few years since our last meeting), he did, at my request, recall the Hilton twins (as the old joke goes, "Maybe you don't remember us, but..."). "Those Hiltons were good girls," Whitey said before devouring his brisket. No kiss-and-teller he.

In a society that seems to cherish "I" and "me," the power of two is surprisingly compelling. In our mythology, in our subconscious, in our art and literature, we are intrigued by duality. Leslie Fiedler waxes provocatively on this theme in his book *Freaks*. You may enjoy the story of Roly and Poly, who open Herbert Gold's *The Man Who Was With It*, or Mark Twain's fictionalized account of the Tocci brothers in *Those Extraordinary Twins*. Twain, like Nabokov and John Barth after him, was compelled to write about Chang and Eng. Katherine Dunn genetically engineered the wonderful piano-playing twins Electra and Iphigenia in *Geek Love*. Difficult to top, however, is Woody Allen's succinct reckoning of Siamese twin boys: "One washed and the other got clean."

In my own career I have enjoyed the dubious distinction of transforming, for a feature film, a pair of handsome identical twin teenage girls into the conjoined variety (by applying a specific but non-toxic glue favored by mendacious showmen).

In the small, ephemera-laden flat in West Hollywood where I used to live, I was visited by a mortgage broker embarking on a career as film producer and sporting the magnificent *nom de cinéma* of Mars Maccabee. He wanted to talk about a "bio-pic" on the lives of Chang and Eng, and was to be accompanied by his would-be director, Leonard Nimoy. As Nimoy was late to arrive, Mars assuaged me by announcing that the five-inch-wide ligature that would connect the actors playing Chang and Eng would be created by the same effects-wizard who fabricated Mr. Spock's ears.

Mr. Nimoy did in due course appear. He solemnly regarded my cache of prints, pamphlets, and playbills, asked a few cautious questions, and departed into the night with the valiant Maccabee by his side. To my knowledge, the film never reached the ligature stage.

A
CATALOGUE
OF THE
RARITIES
To be Seen at
Don Saltero's Coffee-House
IN
CHELSEA.

To which is added,
A Compleat LIST of the Donors thereof.

The Twelfth EDITION.

1 THE Model of our Blessed Saviour's Sepulchre at *Jerusalem*
2 Painted Ribbands from *Jerusalem*; with the Pillar to which our Saviour was tied when scourged; with a Motto on each
3 The Four Evangelist's Heads cut on a Cherry Stone
4 A Crucifix
5 A small Skull, very curious
6 Two Baskets made of Cherry Stones
7 A Giant's Knife & Fork, Padlock & Key
8 A curious Pair of Scissars
9 The Bark of a Tree, which when drawn out appears like fine Lace

A 10 A

COFFEE

I'VE NEVER HAD A CUP OF COFFEE in my life. Neither has my wife. Not that this was some criterion necessary for the posting of nuptial banns. It does at first glance, I admit, make me an unlikely connoisseur of coffeehouse culture. On the other hand, I am a longtime student of public exhibitions, and it is here, where beverage and ballyhoo combine, that I stake my claim.

The first English coffee shop is said to have been opened in Oxford in 1650, its proprietor listed only as "Jacobs the Jew." The beverage itself, a known intoxicant, was both criticized and celebrated. The diversity of the coffeehouse clientele also drew both invective and enthusiasm. A broader mix of classes rubbed shoulders there than in almost any other establishment of the day. Entertainment extended this democratization, or maybe it was just great advertising. As they sipped, customers were treated to displays of rarities that had previously been locked away in private cabinets of curiosities that could be seen only by their wealthy owners and a few acquaintances.

James Salter, dubbed "Don Saltero," was a master of the allied arts of barbering and dentistry. He opened a coffeehouse in London in 1695. It was stocked with artifacts that were primarily discards or duplicates from the great scientific collection of Salter's primary benefactor, Sir Hans Sloane.

Don Saltero's Coffee House was London's first public museum. The more impressive assemblage of the official British Museum, also based on Sloane's accumulations, did not open until 1753.

Don Saltero's was crammed full of oddments. Although these were displayed in no particular order, they could be divided into categories. The largest was natural history. Preserved or skeletal remains were offered in abundance. If you were fond of marine life, for example, you might have viewed a sea armadillo, a grunting fish, a cuckold fish, the jaw of a skate with five hundred teeth, and a mermaid.

Among the advertised man-made treasures you could gaze upon were a pair of dice used by the Knight's Templar, a deck of Spanish playing cards, Mary Queen of Scots' pincushion, a Negro boy's cap made of a rat's skin, or a tiny calligraphic rendering of "King George's effigies; containing the Creed, Ten Commandments, Prayers for the Royal Family, the 21st Psalm, and the Lord's Prayer [inscribed] in the compass of a Silver Penny." For the devout there was a jumble of relics: you could gaze upon the four Evangelists' heads carved on a cherry stone, a set of beads consecrated by Pope Clement VII made of the bones of St. Anthony of Padua, or a pair of nun's stockings.

It may be prudent to repeat here the warning expressed by Richard Steele when he visited Don Saltero's in 1728: "He shows you a straw hat, which I know to be made by Madge Peskad, within three miles of Bedford; and tells you, it is Pontius Pilate's wife's chambermaid's sister's hat."

Don Saltero published a long and laconic list of exotic items. One redundancy may betray a fascination with cunning mammalian equipment. In my 12th edition of the catalog from 1741, items 141 and 192 are both labeled "the pizzle of a raccoon."

In the modern java establishment, variety exists only in the faux Italian neologisms of small, medium, and large, and the interesting taxonomies of the past have been transformed into a daunting array of beverages perhaps best enumerated by Steve Martin in *L.A. Story*:

> *"I'll have a decaf coffee."*
> *"I'll have a decaf espresso."*
> *"I'll have a double decaf cappuccino."*
> *"I'll have a half double decaffeinated half-caf,*
> *with a twist of lemon."*

TAKING IT ON THE CHIN

LONDON BRIDGE, AS STUDENTS of geography may know, is now in Lake Havasu City, Arizona. The chainsaw magnate and oil baron Robert McCullough purchased the crumbling landmark in 1970 for $2.4 million. The newspapers called it the highest price ever paid for an antique.

Although I am as covetous as most collectors, it was not the acquisition of the bridge that made me pine. The antique I sought was a playbill, the printed announcement for the original dedication of London Bridge in 1831.

The event was grand. Shops were closed and business was suspended. Londoners packed both banks of the Thames, climbed church towers, and perched on barges. The more privileged spectators watched from specially constructed grandstands. A host of barons and baronesses, dukes and duchesses, and King William IV arrived to much fanfare.

To entertain the huge throng on this majestic occasion there was a military band, a group of German minstrels, "the celebrated Siffleur, and the still more celebrated performer Michael Boai." Lovers of unusual entertainment would have recognized the "celebrated Siffleur" as the whistler Herr Von Joel. He was frequently billed as "The Human Flageolet," but the true champion of "muscular melody" was the headliner, Michael Boai. I must confess that I coveted the playbill of the festivities for his participation alone. And here is why:

Boai was billed as "The Celebrated Chin Chopper." He played his face. His ax was his chin. He began by wetting his mouth and the first two fingers of each hand. He would then strike his chin, punching, prodding, and plunking a prodigious array of notes.

Other chin players were noted in London as early as 1712, and I myself shared the bill with the expert "face player" Marty Lebenson. We toured across Canada in the 1960s with an old-time music and magic extravaganza called "The Busted Toe Mud Thumper Show." Marty was able to produce a variety of pleasing tunes by striking his face with his hands. He could keep an audience in rapt attention as he improvised his solos. He went on to become the leading exponent of the slap-tongue harmonica.

But to take nothing away from my old friend Marty, Michael Boai could produce notes over an astonishing range of two and a half octaves. His half notes, too, were accurate, and according to the *Literary Gazette*, he could "execute chromatic passages, however difficult, with all the taste, rapidity, and precision of the violin and the piano forte."

Boai, who hailed from Mainz, Germany, showed musical talent from the age of six. But his family was so poor that they could afford no instrument. Undaunted, Boai perfected the art of chin playing, and he was heralded at the courts of Munich, Dresden, Berlin, and Copenhagen before his English debut. He performed in the provinces and at major London venues in the 1830s: Egyptian Hall, Astely's Circus, the Strand, the Theatre Royal Surrey, and Vauxhall Gardens. His musical arrangements and portraits were sold on site.

Although he could strike his chin repeatedly without pain, a long program caused considerable fatigue, and intermittent relief was provided by his wife, on vocals and guitar. Although Boai's recitals were praised by critics, one commentator complained that "the peculiar movements of the performer's head and hands threw an air of the ludicrous over the whole exhibition."

Boai dazzled his fans with a large repertoire of popular airs, waltzes, rondos, and melodies of his own composition. He was famous for his rendition of the overture to Kreutzer's *Lodoiska*. For his finale on patriotic occasions like the dedication of London Bridge, Boai flourished his chin-pounding variations on "Rule Britannia."

DIRTY DICK

I HAVE BEEN SQUIRRELING AWAY books, prints, playbills, posters, and ephemera, with some serious intent, for more than a quarter of a century. The major areas in which I specialize are conjuring, deception, unusual entertainments, and remarkable characters. The subgenres can be as idiosyncratic as dictionaries of underworld slang, prints of pickpockets, and the literature of sagacious animals.

When I look back over my accumulations, nothing gives me more pleasure than the pieces I have obtained on Matthew Buchinger, "The Little Man of Nuremberg." Born in Germany in 1674, Buchinger played a multitude of musical instruments, danced the hornpipe, exhibited trick bowling shots, demonstrated skill at dice and cards, and was an expert in sleight of hand and a master calligrapher. All this in spite of the substantial handicap of a twenty-eight-inch frame lacking arms, legs, thighs, and hands. I have been a bit obsessive and tremendously fortunate in assembling a large collection of materials by Mr. Buchinger and other armless calligraphers.

Now I am going to confess that I collect something odd.

I have conscientiously accumulated memorabilia on Nathaniel Bentley, a late-eighteenth-century hardware store proprietor. Mr. Bentley is an oft-chronicled figure in a category of literature called "Remarkable Characters." Beginning in the latter half of the eighteenth century, prints of these worthies were passionately collected, and compilations of these images were frequently published. Among the glorious personalities immortalized were Martha Davis the Horned Woman, Thomas Parr the one-hundred-and-sixty-two-year "Olde, Olde, Very Olde Man," Moll Cutpurse the cross-dressing, pickpocketing prostitute, and the aforementioned Matthew Buchinger.

Why, you must be pondering, would a proprietor of a hardware store be included among such singular attractions? Bentley was a wealthy, well-educated, and well-respected owner of a housewares emporium in the heart of London. So concerned was he with matters of fashion and style that his hair was dressed by a court perruquier and he was known as "The Beau of Leadenhall Street." An eminently eligible bachelor, he broke many a heart when he announced his engagement. When his fiancée died suddenly, however, he was so bereft, so unassuaged in his grief, that he became a major proponent of the "Oh What's the Use" philosophy of life.

From the date of his woman's unfortunate demise, he never once cleaned his shop or his home again. When a friend chided him for his less-than-scrupulous personal habits, he replied, "If I wash my hands today, they will be dirty tomorrow." This behavior generated a peculiar fame: Nathaniel Bentley became known as "Dirty Dick the Dirty Warehouseman of Leadenhall Street."

In the forty years in which he refrained from dusting and dousing, he became the subject of gossip, chapbooks, poems, and engravings. He is included in almost every compilation of Remarkable Characters. I have secured numerous prints and publications chronicling his fame. Perhaps none are more unlikely prizes for the collector than the poem authored about Dirty Dick by the respected Victorian poet William Allingham and published in an ephemeral pamphlet advertising a London wine shop. Fortunately Mr. Allingham's reputation does not rest on these verses:

> In a dirty old house lives a Dirty Old Man,
> Soap, towels, or brushes were not in his plan;
> For forty long years, as the neighbours declared,
> His house never once had been cleaned or repaired.
>
> The old man has played out his part in the scene,
> Wherever he now is let's hope he's more clean;
> Yet give us a thought, free of scoffing or ban,
> To that Dirty Old House and that Dirty Old Man.

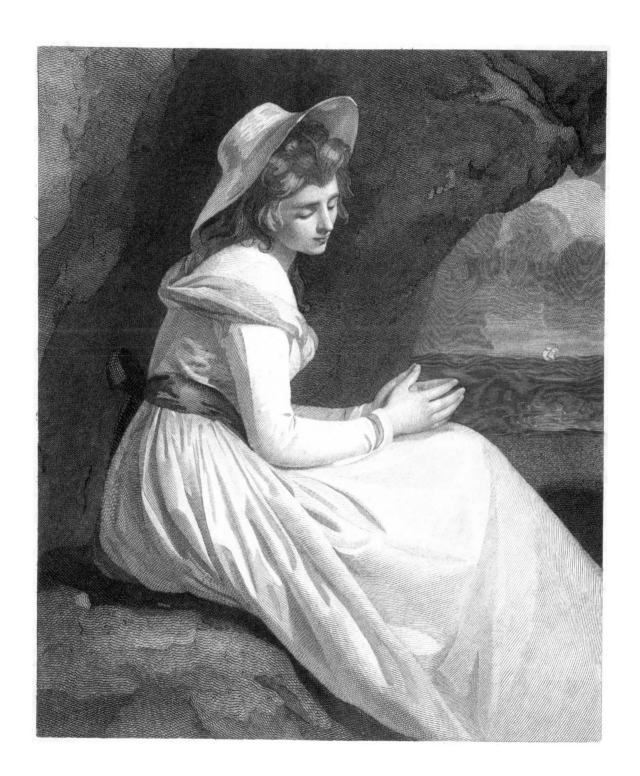

THAT HAMILTON WOMAN

THE PERMANENT COLLECTIONS OF museums often seem to gather a bit of dust, while visiting exhibitions are heavily hyped. To remedy this injustice my friend Victoria Dailey rallied a number of her acquaintances to write about favorite paintings in the permanent galleries of the Hammer Museum in Los Angeles. I was attracted to a lovely portrait by the eighteenth-century artist George Romney, *Emma Hamilton as Ariadne.*

Emma Hamilton was one of the beauties of her age: in Romney's painting she appears in a modest frock and sun hat. She looks down, away from the sea, almost in the attitude of prayer—is she really pining for her dear departed Theseus? The portrait gives no hint of how lauded, objectified, gossiped about, ridiculed, and flat-out famous she would become. A prominent courtesan, she turned Sir Joshua Reynolds, Thomas Gainsborough, Angelica Kaufmann, and Benjamin West into painterly paparazzi. She was satirized by James Gillray and Thomas Rowlandson, the greatest caricaturists of the time; she was dissed by Horace Walpole and discussed by Goethe.

She was a major celebrity in her own day, but she has hardly been forgotten in ours. Here are just some of the recent works that find her worthy of mention: Emma was the subject of the a full-length biography by Flora Fraser. She was a central character in a show at the British Museum called "Vases and Volcanoes" about the collecting passions of Sir William Hamilton, her aged and cuckolded husband. She was a protagonist of the novel *The Volcano Lover* by Susan Sontag, and a much-discussed figure in a recent biography of Admiral Nelson, whose mistress she was. She appears in *The Cambridge Guide to Theatre* in the entry on "nudity." She was chronicled in a book on monodramas published in Stockholm, and she was portrayed by Vivien Leigh as *That Hamilton Woman* in the 1941 film also starring Laurence Olivier.

For me, Emma is important for her role in the history of unusual entertainment. She adorned an eighteenth-century institution as unusual as could be imagined: James Graham's "Temple of Health," which opened in London in 1779. Graham was a doctor, showman, sexologist, and quack; he offered some sound medical advice and certifiable ravings. In an age that granted remarkable privilege to first-born sons, he established a monument to fecundity. He claimed to aid in "the propagation of beings, rational and far stronger and more beautiful in mental as well as bodily endowments than the present puny and nonsensical race [that occupies] most parts of this terraqueous globe."

One of the early attractions of this unholy shrine—in which couples were charged a whopping £50 for a spin in his "Celestial Bed"—was a barely clad priestess said to be the beautiful Emma.

Her fame was to outlive the doctor's, and not just as the subject of a slew of lovely paintings. Emma Hamilton may justifiably lay claim to influencing, if not originating, a whole genre of entertainment that continues to this day.

Emma assumed the roles of characters of antiquity, as a living embodiment of famous paintings. Manipulating her shawl and taking advantage of dramatic lighting, she would re-create classical vignettes recognizable to the distinguished visitors at her husband's salon. Emma became truly adept at using her beautiful physiognomy and form to create what she called "attitudes." These three-dimensional paintings eventually became an entertainment known as "tableaux vivants," "poses plastiques," or "living pictures." More of this in a subsequent essay, but for now, a nostalgic nod to the woman who parlayed portrait-sitting into performance art.

In consequence of the very numerous and earnest requests made that

MR DUCROW

Should appear once more before his departure in the celebrated Melo-Drama of

THE DUMB MAN OF MANCHESTER.

He has very kindly consented to repeat that Character this Evening in addition to his celebrated Performances in

RAPHAEL'S DREAM.

THIS PRESENT EVENING, SATURDAY, DECEMBER 23, 1837, will be performed the Melo-Drama of The

DUMB MAN OF MANCHESTER

The Lord Chief Justice by Mr GRAHAM—Mr Palmerston, a Barrister, by Mr W. H. CRISP,
Edward Wilson, Nephew to Mrs Wilson, by Mr MONTAGUE STANLEY—Tom, the Dumb Orphan, Brother to Jane, by Mr DUCROW,
Crispin, Welter, Master of the Golden Boot, by Mr LLOYD, in which Character he will, with Miss Newton, introduce the Celebrated Duet of
WHEN A LITTLE FARM WE KEEP.
The Usher by Mr TREMAINE—Constable by Mr STEWART—Factory Men by Mr AITKIN and Mr SAUNDERS,
Mrs Wilson, Widow of a Rich Manufacturer, by Mrs W. H. CRISP—Nelly, a Milkmaid, by Miss NEWTON—Jane Wilson, Wife to Edward, by Miss VINING.

After which the favourite Operetta, in Two Acts, called

THE WATERMAN.

Old Bundle by Mr JOHNSON—Robin by Mr LLOYD—Tom Tug by Mr BARKER, in which Character he will sing:
**YE MARINERS OF ENGLAND——THEN, FAREWELL MY TRIM BUILT WHERRY,
THE JOLLY WATERMAN——AND THE B Y OF BISCAY.**
Mrs Bundle by Miss NICOL—Jane by Mrs TURNBULL—Anne by Miss EIIS ORTH—Betty by Miss COVENEY,
Wilhelmina by Miss HYLAND, in which Character she will sing
A FAVOURITE BALLAD.

The whole to conclude with the Classical Representation, entitled

RAPHAEL'S DREAM

OR THE EGYPTIAN MUMMY AND STUDY OF

LIVING PICTURES.

AS PERFORMED		IN A THEATRE
BY		BUILT
ROYAL COMMAND		FOR THE OCCASION
BEFORE HIS		IN THE
LATE MAJESTY		Royal PAVILION,
WILLIAM IV.		BRIGHTON.

Raphael, the Celebrated Italian Painter by Mr W. H. CRISP—Bellerina by Miss HYLAND.

The Mummy and the whole of the Pictures by Mr DUCROW.

The Specimens of Ancient Art commence with

THE MUMMY,
Or IDOL,
A figure from the Book of Fate, an antique bas-relief.
Egyptian Prophet
Administering an Oath to the People!
From Belzoni's Collection—The
STATUES
Of the Grecian and Italian Schools, commence with
PROMETHEUS
AND
Vulture on the Rock.
COLOSSEUM IN REGENT'S PARK.

The Imaginary
MOVING FORMS
Of Sculpture in
RAPHAEL'S DREAM.
HERCULES' COMBAT
WITH THE LION,
In Six Positions.
DISCUS throwing THE QUOIT.
THE SLAVE REMOLEUR
Sharpening his knife while overhearing the Conspirators
Ajax defying the Lightning

Raphael's Dramatic Vision concludes with The
DYING
Gladiator!
COLOURED SPECIMENS!
An Historical Tableau will represent
Mercury Rising from the
EARTH
AT THE CALL OF JUPITER,
From the celebrated Figure of John of Bologna.
SAMSON
Bearing away the GATES.

On Monday, December 25, the Theatre will be Closed
On Tuesday JOHN OF PARIS—Mr Ducrow's Performances—And THE SPOILED CHILD
On Wednesday, the Last Night of Mr Ducrow's performing in Edinburgh this Season,
On Thursday the Theatre will be Closed—And on Friday will be produced
THE NEW GRAND CHRISTMAS HARLEQUINADE.

LIVING PICTURES

THE PAGEANT OF THE MASTERS takes place in Laguna Beach, California, as it has every year since the 1930s. Famous paintings are here re-created by human actors. The players don thick makeup to simulate brush strokes. They pose to live music and earnest narration. There is something otherworldly about this extreme example of the art of standing still in our hectic world.

This tradition goes back to Emma Hamilton, the subject of our last vignette, the eighteenth-century courtesan and superstar sitter to famous painters. She and another unlikely proponent, the great circus equestrian Andrew Ducrow, were the popularizers of "Living Pictures." In the 1820s, Ducrow, in an act called "Raphael's Dream," posed on horseback and subsequently on the stage. He was heralded for his faultless form and grace, as he represented Mercury, Prometheus, or the Dying Gladiator.

Such presentations were imitated in America and were popular on the Continent as well. In 1846 Professor Keller from Berlin made a strong impact in Great Britain and *The Spectator* dubbed him "the most intellectual of living models."

Critics reacted to the sexuality of the show by celebrating Keller's "fine physique and form," and gushed over a scantily clad female beauty "that no marble Venus could ever match." But Keller also presented chaste children and religious themes. "Living Pictures" amalgamate high art and low, sex and sanctimony, connoisseurship and concupiscence.

In the same year that Keller was a hit, the self-dubbed "Lord Chief Baron Renton Nicholson," a reprobate writer, jailbird, and theatrical judge, unjustifiably claimed credit for introducing "tableaux vivants" in England. His almost nude "posers" did, however, launch the art on a prurient path that eventually led to burlesque—just one of the many show-business angles inspired by the living statues.

In the magic world, the "Fakir of Oolu" insisted that his floating lady strike poses while suspended in midair. Wax tableaux are also related to this versatile art form, and in Stephen Sondheim's and James Lapine's *Sunday in the Park with George*, Seurat's painting came to life on the Broadway stage.

The music hall, the dime museum, and the vaudeville house all presented "tableau" acts. For Dick Alden's presentation, "Dreams in Marble," his troupe was completely dusted in white, while other performers covered themselves in more dazzling substances. The Cirque de Soleil show "Quidam" featured a splendid gold-painted acrobatic act called "Statue-Vis Versa." This reminds me of a story from the 1920s, told to me by the great illusionist Dai Vernon, as related to him by his friend Emil Jarrow.

Jarrow, a superb comedy-magician, was then one of the highest-paid acts in vaudeville. He once shared a bill with a Prussian dog trainer. On the same program was a classic posing act in which two fellows covered themselves from head to foot with gold sparkle paint.

One day, as Jarrow was sitting backstage, the star brindled bulldog approached him. Jarrow noticed the pot of gold paint used by the acrobats. As no one else was around he "schmeered" the paint over the formidable nuggets—I believe that was the word he used—of the dog. That night the act received a much stronger reaction than usual. As the dog pranced on its hind legs the audience roared, and the trainer kept raising his hands to milk the crowd for a response he did not comprehend. As the ovation continued, he finally turned around and saw the dog standing tall in the reflected glory of the theatrical lighting. He rushed off stage and grabbed the fire ax in search of the culprit, who had escaped into the darkness.

"Vernon," said Jarrow, relating the story with his thick accent, "ven that spotlight hit dem balls it vas a ting of beauty."

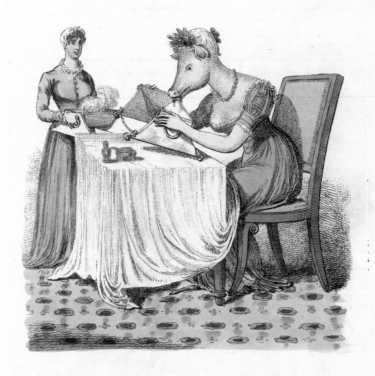

THE PIG-FACED LADY

OF

MANCHESTER SQUARE.

DRAWN AND PUBLISHED BY HER LATE ATTENDANT, WHILE AT DINNER.

THE above Print is descriptive of a Female prodigy which has existence at the West End of the Town, in the person of a Young Lady of the highest rank and expectations.

Various are the reports which have gained circulation as to her Habits, Manners, Disposition, and Accomplishments, but all rest upon mere surmise, as she is seldom or ever seen; she is perfect in her figure upwards to the head, which is that of a *Pig*. She feeds out of a Silver Trough, as represented in the above Print, at times is incapable of giving any other expression of her ideas than a *grunt*, and has not unfrequently been a source of terror to those who are employed about her person.

Offers of marriage have been made to her, by interested fortune-hunters, amongst whom she is, doubtless, an object of irresistible attraction, in consequence of the dazzling splendor of her family con-nections. In all the higher circles she is the universal topic of conver-sation; and curiosity is hourly employed in speculating upon the pos-sible circumstances of her future life, as it is so greatly to the interest of her family that she should not die without issue, lest the title which distinguishes it should become extinct.

Once or twice she has ventured to appear at a private Masquerade, a Masked Ball, &c. and on these occasions the elegance and agility of her movements have drawn to her the attention and unbounded ap-plauses of the first *coteries* of fashion. In taste and stile of execution on the piano-forte she is as much a prodigy as in personal appearance; the most difficult pieces of Handel producing to her no apparent labour or difficulty. She is now 22 years of age, and thus early gifted with accomplishments, it may be easily conceived that she will bye and bye, in spite of the hostility of nature, be accounted the *ne plus ultra* of feminine perfection.

Sold at 98, Cheapside; 50, Piccadilly; and at all Book and Printsellers.

JONES AND CO. NEW STREET.

(PRICE ONE SHILLING.)

MISCONCEPTION

It is well known that newborn animals become strongly attached to the first creature that they see. I turn to a darker form of maternal imprinting: the theory that traumatic stimulus during pregnancy shapes the appearance of the child. This theme spans centuries, continents, and disciplines. In the world of entertainment, some of the most far-fetched anomalies have been promoted as the consequence of gestational shock.

According to the story of 1618, a pregnant mother refused to help an alms-seeking beggar, who then prophesized, "As the mother is hoggish, so swinish shall be the child." The baby, named Tannakin Skinker, was born with a human body and a pig's head.

In the thirteenth century a noblewoman who slept under a picture of a bear subsequently gave birth to a child with ursine fur and claws. A "solution" was instituted by Pope Martin IV. He decreed that all pictures and sculpture of bears in Rome be destroyed.

Among the more famous offspring of the genre is Joseph Merrick, the Elephant Man, who has been the subject of dramas on both stage and screen. His mother, you may have surmised, was supposedly stepped on by an elephant when pregnant.

A Polish precursor to Chewbacca, Stephan Bibrowski, was exhibited in the early twentieth century as "Lionel the Lion Faced-Man." The long silky hair that covered his body was attributed to a parturient ordeal—during pregnancy his mother had witnessed his father being torn apart by lions. Jan Swammerdam, the famous seventeenth-century Dutch anatomist, recorded the account of a pregnant woman frightened by a black man. She immediately hurried home and scrubbed her body to "keep the baby from turning black." When the child was born it was predominantly white, but with black splotches in all the places she had been unable to reach in her ablutions.

Many years later, Hannah West, a white child born with one black shoulder, arm, and hand, provoked not only speculation about maternal imprinting, but, remarkably, a commentary on one of the most important of modern scientific theories. Hannah's mother was frightened when she stepped on a lobster before giving birth. How this elicited to a two-toned child is not clear, but in his 1813 paper inspired by the case, Dr. Charles Wells, a Scottish scientist, authored the first pre-Darwinian commentary on natural selection.

Ann Leak was an armless woman who demonstrated skills such as lace-work and hair weaving at Barnum's Museum in the 1870s. Like many show folks, she sold a souvenir pamphlet about her life at the exhibition. George Middleton, the circus man, relates a story not included in the booklet: "She told me her father was a man who drank a great deal... When her mother saw him after one of his ordeals he had his overcoat thrown over his shoulders without his arms in the sleeves. Ann claimed that this was the reason she was armless."

In 1726 Mary Toft was the perpetrator of one of the most famous hoaxes of all time—the supposed birthing of numerous rabbits. During her pregnancy she claimed that she was surprised by a rabbit and gave chase, but was unable to catch it. She became obsessed with the creatures to the point that she fervently wished to devour them. Eventually she gave birth to numerous rabbits, or rather parts of rabbits. King George I sent his unpopular, and distinctly untalented, anatomist St. Andre to investigate, but he and many others were fooled. Toft concealed rabbit parts in a secret pocket in her skirts and introduced them into her "warren" at appropriate times. After the appearance of some eighteen critters, Ms. Toft was thoroughly debunked.

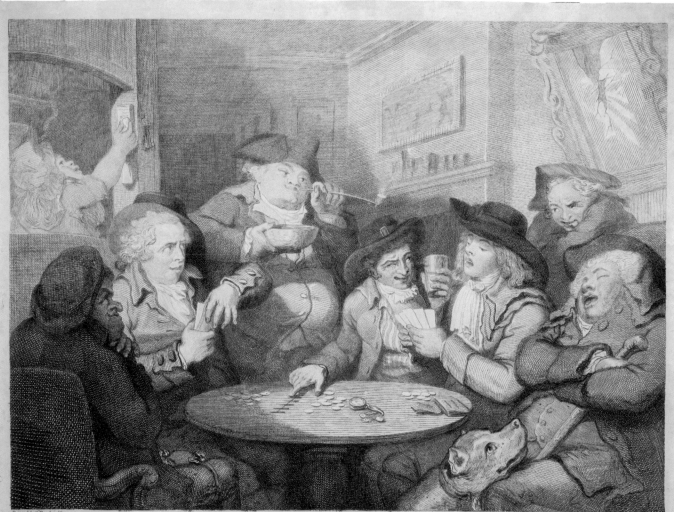

Painted by T. Rowlandson.

Etch'd by I.K. Sherwin.

SMITHFIELD SHARPERS
or
The COUNTRYMEN DEFRAUDED.

Old Trusty with his Town made Friends,
To gentle Sleep himself commends,
With Tray upon his knees;
Whilst Tom his Son, all eager, gaping,
Expects each moment, he'll be scraping
The Treasure up he sees.

Mean time the Happy Tribe are plotting
By forcing liquor, winking, nodding,
To cheat the Youth unlearn'd,
Who to his cost, will quickly find,
Nor Watch, nor Money, left behind,
And Friends to Sharpers turn'd.

Publish'd by T. Palser, Surry Side, Westminster Bridge.

SHARPS AND FLATS

HELLO, SUCKERS! The con man has always tried to bilk the pigeon, the coney, the gull, the jay, the bates, the flat, or the mark of their hard-earned geetus. Our language is rich in colorful synonyms for these patsies and for the swindlers who amiably relieve them of their cash.

Pigeon, gull, and coney are venerable terms for potential victims, all likely based on the vulnerability of the animals they represent. A pigeon was the eighteenth-century dupe of a dice or card hustler, and a gull, short for seagull, was the target of similar cheaters a century earlier. The fellow who lured the sucker into the hustler's net was known as a gull-groper. The playwright Thomas Dekker described a modern-sounding hustle in which a young gull was allowed to win in the early stages of gaming, only to be plucked clean at the finale. Continuing the analogy, Dekker wrote that "the gull...hath in the end scarce feathers to keep his own back warm."

A coney, the earliest of these terms, was long the common word for rabbit, an animal of proverbial simplicity. Coney Island was so named for the rodentia that formerly inhabited that spot in prodigious numbers. In the 1590s, the hack writer Robert Greene described the swindler who set his trap for these suckers as a "coney-catcher." Greene may be best remembered for an avian put-down of his young rival Shakespeare, whom he called an "upstart crow." Almost as notoriously, Greene died of a surfeit of pickled herrings.

Before our language assumed the more geometrical approach to games conducted "on the square" or the "rounders" who take them off, we also had sharps and flats. England's greatest nineteenth-century magician, John Nevil Maskelyne, penned a book called *Sharps and Flats* to warn the public about the evils of card and dice cheaters. "Metaphorically," he stated his intention, "flattening the sharps, and sharpening the flats."

The Victorian rascal Baron Renton Nicholson wrote about the consanguinity of sharps and flats: "There is not a word in the cant or flash vocabulary, nor indeed in the English language, taken in its right sense and meaning, that conveys so much, and is so generally applicable as the simple monosyllable flat. There are flats of every rank, grade, and station in society, in every part of the known world, and, I dare say, in the unexplored portion also... Flat is the parent, progenitor, and preserver of sharp, the very root and sap of its existence. Without flats sharps would become extinct."

Many of these low-life terms were considered too base for Dr. Samuel Johnson's great eighteenth-century dictionary, but they are an essential ingredient on the circuitous path of language from cant to colloquialism to slang to common usage.

I have become an unabashed fan of "Pedlars' French," "St. Giles Greek," "Thieves Latin," and "Flash Lingo." I have gathered glossaries of criminal argot, canting dictionaries as they are called, dating to the sixteenth century.

One of my favorites is by John Bee (né Badcock), the Regency lexicographer, who defines flat as "one who pays money when he can avoid it." Here is a portion of the title page of his slang dictionary of 1825:

Particularly Adapted To The Use Of The Sporting World, For Elucidating Words And Phrases That Are Necessarily, Or Purposely, Rendered Cramp, Mutative And Unintelligible, Outside Their Respected Spheres. Interspersed With Anecdotes And Whimsies, With Tart Quotations And Rum-Ones; With Examples, Proofs, And Monitory Precepts, Useful And Proper For Novices, Flats And Yokels.

[Then follows the irresistible epigram:]

"Words not in Johnson, — no fudge."

FROM:
JOURNAL OF THE JEWISH PARANORMAL.

PORTRAIT OF THEODORE HERZL
APPEARS ON A TORTILLA !

JESUS ON A TORTILLA

Staring at a stop sign in New Orleans in the 1970s, many observers thought they saw the face of Richard Nixon. Others, viewing from the same angle, swore they discerned Ulysses S. Grant. A teenager recognized the rolling-paper icon Captain Zig Zag, but his testimony was largely discredited. The sign, which generated large crowds and traffic jams, was slated for removal. The policeman assigned to the task said that, to him, the stop sign looked like a stop sign.

A combination of dingy windows and active imaginations has given rise to a category of urban legend and iconographic phenomena known as "pareidolia." These optical simulacra cross the boundaries of continents and cultures. While Westerners often see the religious imagery of their own traditions, such as the face of Jesus or the Madonna, a waterfall in Taiwan revealed the features of the Buddhist goddess Kwan Yin.

Here are a few examples from my files:

In 1977, Episcopal church-goers in Shamokin, Pennsylvania, noticed the face of Jesus on a folded tabernacle cloth. In Houston some years ago a stain caused by melted ice cream revealed the visage of the Virgin of Guadalupe. In Estill Springs, Tennessee, a likeness of Jesus was witnessed on the surface of a General Electric freezer, and in San Antonio, Texas, many people flocked to the home of Mary Ibarra to see a the Virgin Mary reflected in the finish of a '75 Chevrolet.

A "vanishing hitchhiker" was sighted on the New York State Thruway in 1973. Described as a "beautiful young hippie in shining white clothes," he reminded passing motorists of Jesus. In 1987, Italian police were less than enthusiastic about the sighting of Jesus on a window in the village of Suppino, south of Rome. Forensic analysts declared that the portrait was an optical illusion produced by pollutants deposited on the glass. In Fostoria, Ohio, local residents delighted in the image of Christ that manifested itself on a soybean oil storage tank in 1986.

I have often used my archives as the inspiration for performance pieces. More than twenty years ago my repertoire included this:

I would read an actual newspaper account about the face of Jesus appearing on a tortilla prepared by a Mrs. Rubio in her home in Lake Arthur, New Mexico. The article mentioned that worshipers by the hundreds had descended on the town where Mrs. Rubio had enshrined the tortilla in a plastic vitrine surrounded by flowers and votive candles. My favorite line was that the Reverend Joyce Finnegan, a Franciscan priest, had "reluctantly blessed the tortilla."

I then asked for a volunteer to join me onstage. I would direct him to select any four corn tortillas from a sealed package and to place them across his knees. I would then say, "Boldly discard two tortillas." These were usually hurled into the audience. After the volunteer examined and initialed the remaining two, he was asked to place one above the other and to keep them between his palms. I urged him to concentrate on a non-religious subject that would be familiar to the audience. Announcing the limitations of my psychic portraiture, I would add, "Keep it simple, I'm not Albrecht Dürer." I would then unabashedly hint at our sixteenth president. "Emancipate your mind," I would begin, as I tugged at my beard. Or, "A penny for your thoughts." After the volunteer indicated that he had settled on a subject, he was instructed to lift up the top tortilla. This revealed not Abraham Lincoln but a "smiley face" etched on the second tortilla. As silly as this was, the appearance of the face was quite startling. I reached into my case and handed him a bottle of Dos Equis and a tin of refried beans as I escorted him back to the audience, saying, "Have a nice day."

SPENCER'S
STARTLING SPECIAL

KID CANFIELD
THE NOTORIOUS
GAMBLER

Kid Canfield exposes
by actual demonstration the
dishonest methods
by which the victims are
fleeced in gambling dens.

Fleecing a victim who at first had been lucky.

The Sleeve Cheating Device.

A Distinctly
Educational Feature

REFORMED GAMBLERS

THE UNWARY PUBLIC HAS ALWAYS needed protection from swindlers, and salutary warnings about cheating techniques have been published since the sixteenth century. Some of the best advice has certainly come from practitioners who have apparently reformed their ways. But exposing nefarious procedures not only protects the innocent, it also educates the unscrupulous. The motives of these debunkers have always been questioned. Were they moral reformers recanting their evil ways, or reprobates trying to generate publicity, book sales, theater tickets, or further opportunities to swindle?

Should we "send a thief to catch a thief"?

The most famous "reformed gambler" of the nineteenth century was Jonathan H. Green. In 1843 he published the first account of cheating at poker in *An Exposé of the Arts and Miseries of Gambling, Designed Especially as a Warning to the Youthful and Inexperienced, Against the Evil of that Odious and Destructive Vice*.

Green was a successful "advantage player," until a religious awakening led to his career as an author of exposés. To augment his income he resorted to personal appearances. On the lecture circuit Green's most engaging ploy involved the exposure of marked cards. He announced that almost every pack available for purchase was pre-marked by the manufacturer. He would then ask for someone in the audience to bring forward a deck of cards that he had never seen. He proceeded to look at the backs of the cards and correctly identify the faces. The gasps of the audience can well be imagined. In an act of serious chutzpah Green had strategically placed a mirror on his lectern that would reflect the faces of the cards as he apparently studied the backs for marks that did not exist.

Other reformed gamblers used their prowess as card and dice cheaters as an opportunity to perform onstage or in films. Among them were Kid Royal, Kid Canfield, and John Philip Quinn. During a long career Quinn wrote a number of books on crooked gambling and gave popular lectures with a high moral tone. Occasionally he sought out magic emporiums in the larger cities. In New York he became acquainted with one of my mentors, Dai Vernon, the legendary sleight-of-hand artist. At one of their meetings Quinn demonstrated some cheating moves and then asked Vernon to steer him to a lucrative game after that night's lecture on the evils of gambling.

Vernon's favorite book was an exposé of cheaters' techniques known as *The Expert at the Card Table*. The official title of this 1902 classic was *Artifice Ruse and Subterfuge at the Card Table*, and its author was listed as S. W. Erdnase — his actual identity has never been verified. The preface suggests a lucid motivation for a gambling monograph, and indeed one of the most effective rationales for any book with which I am familiar: "In offering this book to the public the writer uses no sophistry as an excuse for its existence. The hypocritical cant of reformed (?) gamblers, or whining, mealy-mouthed pretensions of piety, are not foisted as a justification for imparting the knowledge it contains. To all lovers of card games it should prove interesting, and as a basis of card entertainment it is practically inexhaustible. It may caution the unwary who are innocent of guile, and it may inspire the crafty by enlightenment on artifice. It may demonstrate to the tyro that he cannot beat a man at his own game, and it may enable the skilled in deception to take a post-graduate course in the highest and most artistic branches of his vocation. But it will not make the innocent vicious, or transform the pastime player into a professional; or make the fool wise, or curtail the annual crop of suckers; but whatever the result may be, if it sells it will accomplish the primary motive of the author, as he needs the money."

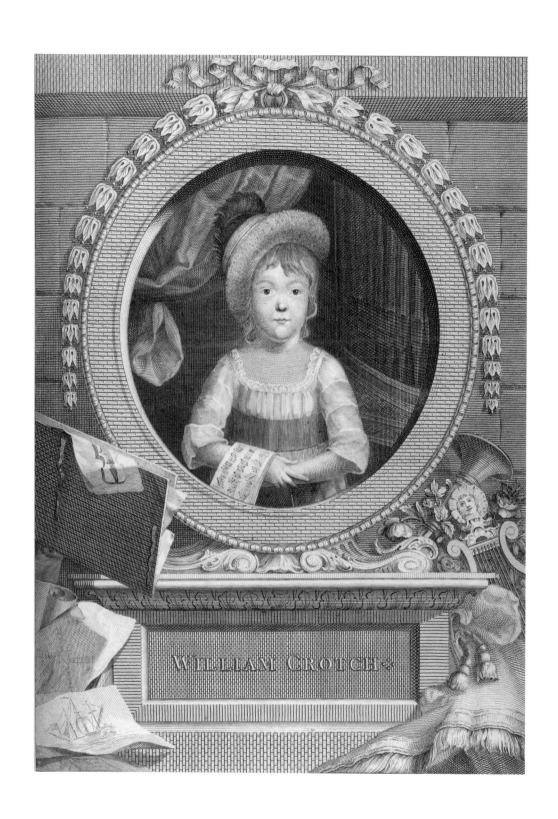

WILLIAM CROTCH.

MASTER CROTCH

"WHY ISN'T HE JUST THE CUTEST brand enhancer you've ever seen," read a cover of the *New York Times Magazine*, profiling the four-year-old skateboarder Dylan Oliver. As I read about the marketing of a bunch of very young extreme sports whiz kids, I thought of William Crotch.

Master Crotch was born in Norwich, England, in 1775. Barely past his second birthday he was picking out "God Save the King" on the family organ, which his father, a master carpenter, had built. According to a contemporary account published by the great musicologist Charles Burney in the *Philosophical Transactions of the Royal Society of London*, William's father boasted of his son's prowess to the neighbors, who laughed at him, thinking that the father was blinkered by fondness for his own child. They recommended that he never mention it again or risk general ridicule.

A few days later the father was ill and stayed home from work. His employer happened by the house and heard music. Annoyed to discover that the carpenter was malingering, he let himself in and was astounded to see that it was the infant who was playing. Word spread and by the next day a hundred townsfolk, it is estimated, gathered to hear young William play the organ.

The child's devotion to practicing also excited attention as William was so obsessed with his music that he would often continue right through mealtimes. The boy also played the piano, harpsichord, and violin, the last by holding it between his legs like a cello. At two and a half years of age he was already able to distinguish any pitch, even quartertones.

Although some accounts say that his abilities were otherwise unremarkable, Burney relates that he was "possessed of a general intelligence beyond his age," and that he had a proclivity for drawing nearly as impressive as

his talent for music. He sketched and painted productively for the rest of his life.

In January of 1779 he was summoned to perform at Buckingham Palace for the royal family. He played ten tunes including the national anthem. William Crotch was then three and a half years old. Other royal and commercial engagements followed, with Crotch variously billed as "The Musical Phenomenon," "The Infant Musician," or "The Musical Child." While still a youngster he studied and played music at both Cambridge and Oxford.

Although Crotch became a respected performer, composer, and musical scholar in later life, he was no longer celebrated as a genius. There is some speculation that the parental pressure in his early years as a child prodigy had caused permanent psychological damage. In old age he was said to be conservative to the point of eccentricity. But *Grove's Dictionary of Music and Musicians* notes that his precocity was almost unprecedented, perhaps surpassing the young Mendelssohn or even Mozart.

As formidably gifted as was Master Crotch, even more remarkable was a contemporary child performer whose name, alas, has not been recorded for posterity. An undated playbill for the famous conjurer Breslaw, just a few years before Master Crotch's precocious appearances, promised this feat:

Act the Third: A Young Italian Lady, about four years old, will turn around quick on the Table for a Quarter of an Hour, without being tired or giddy, and at the same Time she will drink to the Company's Health with a full Glass of Wine, without spilling one drop.

Had this youngster of legendary equilibrium been given a skateboard, one can only salivate at the prospect of her potential endorsements.

GAMBLING WITH SUPERLATIVES

AMARILLO SLIM WON THE World Series of Poker… thirty-some years ago. I'm not sure that qualifies him as "the greatest gambler who ever lived." Nevertheless, this superlative comes blasting forth on the dust jacket of his entertaining memoir. The lanky Texan tells amusing tall tales, even casting himself in a hundred-year-old poker story that he swears just happened. He brazenly compares himself to a host of famous personalities and then attacks Minnesota Fats and Jimmy the Greek for taking the same kind of self-promotional license.

Operators always hype their achievements, and in gambling that vice may be essential, as reputation and bluster can directly affect the course of a wager. If you think a fellow is a little too outrageous in tooting his own horn, wouldn't you want to bet with him just to cut him down to size?

Slim's book made me think of his granddaddy in grandstanding, George Devol, one of the most famous hustlers of the nineteenth century. In 1887, George Devol wrote and published his captivating memoir, *Forty Years a Gambler on the Mississippi.*

The title page states:

A cabin boy in 1839; could steal cards and cheat the boys at eleven; stock a deck at fourteen; bested soldiers on the Rio Grande during the Mexican war; won hundreds of thousands from paymasters, cotton buyers, defaulters, and thieves; fought more rough-and-tumble fights than any man in America, and was the most daring gambler in the world.

Devol portrays himself as so good natured and generous—kicking back partial scores and giving money to charity—that we are inclined to forget what a scoundrel he was.

According to an obituary of July 9, 1903, in the *Daily Picayune*, Devol, having dissipated a monumental fortune, spent much of his last years hawking his book in New Orleans to eke out a living. But I know of only two surviving annotated copies—perhaps they give insight into his true character.

One was owned by the senator R. M. Stimson, whose notes were quoted by John West in his essay in a reprint of the book. Stimson wrote on the flyleaf: "[Devol] was always, and is yet a 'bad egg.'" The other, in my collection, is a presentation copy of the first edition with a tipped in letter by one F. H. Bulio. He wrote: "I despised George Devol so thoroughly that I never gave his book a place on my shelves. For of all the loud-mouthed cowardly petty larceny 'tinhorns' who ever lived he was the chief."

As a kid I was befriended by John Scarne, the talented sleight-of-hand artist who billed himself as "the world's greatest gambling authority." On one occasion, Scarne was visited by a couple of very accomplished magicians, one of whom pushed a deck of cards toward him and asked politely if he would "do something." Scarne slid the cards away, declining to perform, and said, "When you've got the title, whaddaya gotta prove?"

His own account of his exploits, *The Amazing World of John Scarne,* was published in 1956. According to the flap copy, "This is Scarne's life story and tells how he achieved his unique position as The Authority, the only arbiter respected and trusted by all in the gambling world." Scarne promised to relate a host of remarkable but true stories.

Audley Walsh, a policeman and expert on crooked gambling, was Scarne's sometime collaborator. Walsh had an impressive and meticulously classified collection of books. A friend visited him and was surprised not to find Scarne's memoir on the shelves. Walsh said, "Oh, you're looking in the biography section. I keep the Scarne book here, between Grimm's Fairy Tales and Hans Christian Andersen."

SHOT FROM A CANNON

ZAZEL, AN ATTRACTIVE, SCANDALOUSLY clad fourteen-year-old girl, was blasted out of a cannon at London's Royal Aquarium on April 2, 1877. She was not the first to perform this now-standard circus stunt, but there is no doubt that she was the first of her sex, and by far the most prominent early exponent of the act. And there is no doubt that she caused a sensation. She was loaded into the long barrel. The cannon was ignited, and then, with a frightening report, she hurtled out of the gun and flew through the air for seventy feet before landing in a safety net. She was celebrated, debunked, and burlesqued, immortalized in song and portrait, and was unquestionably the hit of the London season.

Her real name was Rosa Richter, and she was tutored by a character known as Guillermo Antonio Farini. This faux-Italian hailed from Ontario, Canada. His given name was William Leonard Hunt. A daredevil high-wire walker and circus performer turned theatrical promoter, he was accused of shady practices in his tutelage of young prodigies, and may have been the real-life inspiration for George du Maurier's famed fictional character Svengali.

He presented trapeze artists, trained seals, ethnological curiosities, and some of the most celebrated freaks of the day. In later life he took up painting and writing, but continued his devotion to the exotic, penning such works as *Ferns Which Grow in New Zealand*.

Farini patented his cannon-shooting apparatus, a variation of earlier devices that he had invented for catapulting gymnasts into the air, in 1875. Farini was embroiled in many legal battles to protect his act. He even tried to trademark the name Zazel to preempt usurpers, such as a "Lazal" act that was attempting to steal his thunder.

When P. T. Barnum asked to engage Zazel, Farini not only refused but also claimed that the legendary impresario was conspiring to abduct his pretty flier, and he offered a thousand-pound reward for information leading to his conviction. Farini's biographer, Mr. Shane Peacock, suggests that this wonderful bit of duplicitous publicity was one reason P. T. called Farini "the most talented showman" he knew. Zazel later toured with Barnum to much success in America.

Were purveyors of such cannon fodder inherently litigious? The Zacchini family, the most famous twentieth-century cannon act, were perhaps best known for a winning a case argued before the United States Supreme Court.

The widespread use of cannon-propelled aerialists has made the turn almost a cliché in circus performance. Perhaps that is why I was only slightly surprised at receiving the following letter in October of 1988, when I was the curator of the Mulholland Library of Conjuring & the Allied Arts. It was from a Galveston advertising agency and addressed to Fricky Jay. It began:

> *Dear Fricky Jay,*
>
> *Our client, The Eye Clinic of Texas, recently restored the sight of a former carnival and circus performer named Claire Boonot Sinclair. Her act in the 1930s consisted of being shot out of a cannon to a height of 175 feet.*
>
> *We are trying to locate the cannon, which we were told was on display in a circus museum in California. The cannon was named the Claire Boonot. Mrs. Sinclair would like to see her cannon again and we are attempting to locate it... The eye clinic will fly Mrs. Sinclair to see the cannon.*
>
> *Enclosed is a photograph of Mrs. Sinclair during her days as a human cannonball. If you can point us in the right direction please call or write.*

Sadly, I was unable to solve the mystery of Claire Boonot Sinclair and her cannon, the Claire Boonot.

The mystery of Fricky Jay is less perplexing.

Mit hoher Bewilligung
wird heute zum letzten Mahl
Herr Weiß, mechanischer Künstler von Paris,
die Ehre haben, sein
Theater der Künste
zu zeigen.

Erste Abtheilung.

Eine Auswahl der neuesten Stücke der Magie oder ergötzenden Physik, und zum Beschluß mit abgerichteten Kanarienvögeln.

Zwepte Abtheilung.

Der mechanische Seiltänzer.

Derselbe ist 4 Schuh hoch, und tanzet auf einem gespannten Seil nach dem Takte der Musik, macht alle nur mögliche Touren, Schwenkungen und Bewegungen auf demselben mit so vieler Geschicklichkeit und Geschwindigkeit, so zwar, daß es dem geübtesten Seiltänzer unmöglich ist, dieselben dieser mechanischen Figur nachzumachen.

Dritte Abtheilung.

Große optische Erscheinungen,
vollkommen nach der Natur sehr künstlich bearbeitet.

1. Ihre Majestät die Kaiserin Maria Theresia.
2. Seine Majestät der Kaiser Joseph.
3. Feldmarschall Fürst Schwarzenberg.
4. Seine Majestät Ludwig XVI. König von Frankreich.
5. Ihre Majestät die Königin Antoinette, dessen Gemahlin.
6. Friedrich der Große, König von Preußen.
7. Ihre Majestät die Königin Louise von Preußen.
8. Peter der Große, Czaar von Rußland.
9. Libussa, Königin von Böhmen.
10. Maria Stuart, Königin von Schottland.
11. Hamlet, Prinz von Dänemark.
12. Feldmarschall Blücher.
13. Wilhelm Tell.
14. Die Jungfrau von Orleans.

Die Erscheinungen werden sich von 3 Zoll bis zu 3 Ellen vergrößern.

Vor diesem: 1. der Kopf des Diablo, der große Teufel genannt, welcher aus Nichts entsteht, die Augen bewegt, und in kolossalischer Größe auf den ersten Platz spazieret, dann verschwindet. 2. Erscheinen fünf Köpfe nacheinander, welche mehrere lächerliche Bewegungen machen werden. 3. Die Stadt Konstantinopel. 4. Mehrere lustige Gegenstände.

Der Raum gestattet nicht, alle die vorkommenden Gegenstände anzuzeigen; des Obengenannten Bestreben ist, sich auch hier des in so vielen Hauptstädten erworbenen Beyfalls zu erfreuen, und sich durch stets neue Abwechslungen die vollkommene Zufriedenheit der hohen Anwesenden zu erwerben.

Preise der Plätze und Schauplatz sind bekannt. Der Anfang ist um 6 Uhr.

UNPARALLELED SUFFERINGS

WHENEVER I AM IN THE WRONG PLACE at the wrong time, I think of Andrew Oehler. His autobiography, *The Life, Adventures, and Unparalleled Sufferings of Andrew Oehler*, was published in Trenton, New Jersey, in 1811.

Born in Germany in 1781, Oehler left home at age thirteen in search of adventure. He had a knack for turning up in the briar patches of life.

In post-revolutionary Paris he was jailed for supposedly violating the chastity of a woman he never touched. In Hamburg he narrowly escaped beheading when he was convicted of a murder he did not commit. On a voyage in the China Sea he was shipwrecked and stranded on a deserted island. On another sea venture his boat was boarded and he was impressed into service by British pirates.

In Mississippi Oehler was robbed by bandits who divested him of his entire fortune, which at the time consisted of four hundred horses. He was assaulted by men who wanted him to reveal the secrets of Freemasonry and was set upon by the brother of a murderer whose conviction was based largely on Oehler's testimony. In the swamps of Pensacola he was stranded when his horse was bitten by a rattlesnake and died. Arriving in Haiti he found himself in the midst of Toussaint L'Ouverture's uprising where, to avoid a firing squad, he accepted a commission in the revolutionary army.

The Albert King of his day, "if he didn't have bad luck he wouldn't have no luck at all."

As a budding balloon ascensionist, he was thwarted when gamblers—wagering he would not succeed—surreptitiously slit his balloon. Finally aloft in a later attempt, he descended only to learn his manager had absconded with all his money.

In Mexico a successful balloon exhibition brought him fame, wealth, and entrée to the highest levels of society. To show his gratitude he invited the governor and his friends to witness his Phantasmagoria show. These theatrical spectacles had become the rage in Europe. In darkened chambers lightning flashed, thunder roared, and guests were shocked with electricity as ghostly figures were projected from a concealed magic lantern.

Transfixed, the audience left without a word. At four that morning Oehler was dragged from his bed, chained, and confined in a pit 150 feet below the ground. Told to prepare for his death, he survived on bread and water for six months until someone convinced the governor that Oehler was not in league with the Devil.

Theoretically, it is the goal of every conjurer to present an entertainment so mind-boggling, so mystifying, that it may be perceived as real. But in any vocation one can garner too much success…

◆

To honor a long-standing contract for a less superstitious group, I arrived in South Africa just in time for the Soweto student revolt in 1976. After my performance I was invited to the home of a prominent newspaper editor for what he euphemistically called "a party." I found myself at a Marxist cell-block meeting. Conflicting interpretation of doctrine signaled an early end to the festivities, as the group, including my host, spilled shouting onto the streets, and dispersed. I was left alone, confused and very, very lost.

Wandering aimlessly, I found myself in front of a theater, and I purchased a ticket for the performance of a circus company from mainland China. Forty-some acrobats in matching Mao jackets rushed onto the stage. They presented a neatly choreographed march, wielding rifles that they would toss, spin, and heft from shoulder to shoulder all the while singing, in English, "*Tie a Yellow Ribbon 'Round the Old Oak Tree.*"

Whenever I am in the wrong place at the wrong time, I think of Andrew Oehler.

CONFESSIONS

I CONFESS, I'VE NEVER THOUGHT of myself as a kiss-and-tell kinda guy. I am a professional keeper of secrets, but I love confessional literature, from tabloid ephemera to canonical classics. I like the *Confessions of St. Augustine*, and Jean-Jacques Rousseau. Thomas De Quincey's *Confessions of an English Opium Eater* was published in 1822. The papa of the drug memoir, he was a surprisingly rousing writer, considering his daily consumption of eight thousand drops of laudanum.

In my own library there are confessions of strolling players, and of confidence men, hoaxers, and scoundrels of every stripe. The nineteenth-century classic *Confessions of a Medium* reveals the inner workings of illusions used to dupe participants in the séance room. The *Confessions of a Ghost Hunter* is the memoir of a publicity-seeking psychic investigator named Harry Price.

The title that prompted this piece, however, was one with which I had no personal or professional connection. It was, as I discovered, full of surprises: The *Confessions of a Pretty Typewriter Girl* is a slim sixty-two pages with a white paper cover featuring an attractive young woman. I found the picture and the title appealing long before I realized the profound impact of typewriter girls on the workforce and on society at the turn of the twentieth century.

When the YWCA began to teach typing in 1881, the idea of women in the workplace was radical enough to make critics fear the collapse of the family and all known cultural values. Even Rudyard Kipling confessed to being nonplused by typewriter girls, and the prurient interest they aroused was so strong that the very mention of typewriters prompted laughs on the vaudeville stage.

By 1924 Proctor's theater featured the act of a sixteen-year-old girl named Bird Reeves who typed, it was claimed, at five hundred words per minute. As part of her turn she would ask for the name of a famous politician and perfectly type a speech of his while simultaneously reciting a completely different oration.

Although *Confessions of a Pretty Typewriter Girl* is not a lurid example of the genre, it is a first-person narrative vivid enough to tempt the voyeur. A resourceful young woman forced to learn a skill conquers the typewriting machine to the extent of nearly two hundred words per minute. She is rewarded with employment at her first interview. At the merest hint of impropriety, however, our heroine leaves the employ of a stodgy legal firm, and in another gesture of independence bicycles to join a group of anarchists in the English countryside. Their hypocrisy alienates her and prompts an early departure.

Although the typewriter girl seems to take us into her confidence, my instincts told me she was not fully forthcoming. I began to inquire into the origins of the pamphlet. It was cheaply published in Chicago in 1908 by Max Stein. There was little information on the title page; not even an author was listed.

I eventually deduced that my pamphlet was excerpted from the novel *Type-Writer Girl* by Olive Pratt Rayner, issued in 1897. In the longer and more conventional version our heroine nimbly dissuades lecherous advances before finding happiness with the "right man." Thus the proud representative of the bold new woman is metamorphosed back into a more conventional girl.

Now that I had unearthed a certain ambivalence behind the typewriter girl, I wondered who the author was. Who could reveal the innermost thoughts of the nineteenth-century working girl, and yet betray such lack of resolve about her destiny?

I must confess that I was not surprised to discover that Olive Pratt Rayner was the *nom de plume* of an established writer. I was surprised to discover that *his* name was Grant Allen.

J. Parry, del.

A. Van. A Soen, Sculp.

GIOVANI BAPTISTA BELZONI

London. Published Dec. 6.1804.by J.Parry, N.5. Bentinck Street

CHANGING PROFESSIONS

IN POLITICS, WE HAVE ELECTED body builders and professional wrestlers to positions of public responsibility and trust. Imposing physical specimens, however, have long enjoyed a celebrity that exceeds the expected.

Although never elected to public office, Giovanni Battista Belzoni, born in 1778, segued from a daunting fairground strongman to a cultural pioneer whose accomplishments shaped the politics of a number of countries. Born to a poor barber in Padua, Belzoni flirted with a career in the priesthood but decided instead to study hydraulics. Unable to secure employment in his chosen field, he went on the road and took work based on his impressive physique. Considered to have one of the finest figures of his day, he struck poses, often in the attitude of Hercules. But it was as a strongman that he first gained fame. In 1803 he performed in England as "The Patagonian Sampson" in a production at Sadler's Wells theater.

His signature stunt was to lift between four and a dozen individuals as he moved gracefully around the stage. He supported his cargo by having them cling to his hips, shoulders, and neck. Later he perched his volunteers on the ledges of an iron girdle that alone weighed more then one hundred and twenty pounds.

As a showman he sported diversity and virtuosity in equal measure. He presented conjuring effects featuring "a man's head off and put on again" and later exposed illusion secrets on stage. He demonstrated not only magic lantern ghost projections called phantasmagoria, but also scientific experiments with hydrostatics and optics. He acted in sketches, performed on the musical glasses, and was a very early (pre-pre-Esther Williams) exponent of aquatic dramas.

Sated with applause, he longed for some greater reward. While performing in Malta he was sought out by a representative of Muhammed Ali, Pasha of Egypt, who engaged Belzoni to build a hydraulically sound water wheel for irrigation. The Pasha bilked him, and he soon found gainful employment with Henry Salt, the English Consul-General of Egypt, who hired him to excavate the stone head of Rameses II. It was a career-changing move. He became smitten with both archaeology and the search for antiquities. The head, commonly called Young Memnon, may still be seen, with many other Belzoni finds, at the British Museum.

In the early nineteenth century, competition for Egyptian archaeological plunder was fierce. Howard Carter, who later found the tomb of Tutankhamen and great fame, described the enterprise: "anything to which a fancy was taken, from a scarab to an obelisk, was just appropriated, and if there was a difference with a fellow excavator, one laid for him with a gun."

Belzoni was the first Westerner to excavate the Valley of the Kings and the first to penetrate the second pyramid at Giza. He located the site of the ancient city of Berenice and countless treasures, all within a few years, before returning to his native Padua. In London once again in 1820, he established his exhibition of antiquities at the appropriately named Egyptian Hall in Piccadilly. He published accounts of his travels and discoveries and became a great celebrity. Although attacked as a plunderer, he was dubbed "the father of modern Egyptian archaeology." In later life he disavowed his showman's roots, but Charles Dickens proclaimed "the once starving mountebank" to be "one of the most illustrious men in Europe."

Belzoni, through technical knowledge, ambition, and physical strength, managed to accomplish the ultimate feat of lifting: he elevated himself.

May our weight-lifting politicians fare so well.

BISMARCK

I HAVE BECOME A FAN of a periodical called *The Believer*, which serves up some fine literary fare in a visually appealing format. In spite of my Luddite sensibilities I found myself perusing the magazine's website. And I can offer no rationale for my compulsion to click on a heading called "Idea Share," where readers propose projects that they are for various reasons unable to undertake personally. Among the myriad suggestions was one that struck an immediate chord: "There should be more novels about sentient animals."

I am fond of sentient animals. I am especially devoted to the more sagacious achievements of brute creation and the related textual genres. Although not dismissive of fictive examples, my own literary tastes lean more to "non." I am fond of the memoir. I am especially impressed by works penned by animals themselves. In my *Learned Pigs & Fireproof Women* I introduced my favorites: *The Dog of Knowledge, or Memoirs of Bob The Spotted Terrier* (London, 1801); and the superb *Life and Adventures of Toby the Sapient Pig, with his Opinions on Men and Manners, Written by Himself* (London, c. 1817).

In recent years my insatiable appetite for such fare has been amply satisfied, but none is more pleasing than the marvelous *Bismarck, The Pig of Genius: His Life and Labours, His Wonderful Education And How He Got It. A Most Extraordinary, Attractive & Instructive Book*. An inflated title for a mere sixteen-page pamphlet, but what can one expect from an eighteen-month-old pig? Printed in Philadelphia in 1871, it was embellished with six charming woodcuts of Bismarck in action. Our hero sported "pointed ears, a shining satin hide, white snowy bristles, sharp clean-cut limbs, keen, sparkling peering little black eyes, and eager looks." He tipped in at a trim 110 pounds.

Bismarck was particularly adept at selecting cards: those used for gaming, those emblazoned with numbers (for the hog's arithmetical computations), those with letters (for displays of orthographical expertise), and those with engraved portraits of presidents of the United States (showing his knowledge of history and political science). Bismarck was exhibited by William M. Allen, who listed himself as the pig's "educator" and established his credentials as homo sapiens by registering the copyright in his own name rather than the pig's.

Because of the rapid porcine growth rate, the careers of performing pigs, no matter how sagacious, were tragically foreshortened. One such unfortunate star named Toby spawned many imitators in the early nineteenth century. The references to Bismarck that I have encountered, however, may all be for the same noble animal. Bismarck, the "Educated and Talking Pig," appeared under the direction of John Clark and was featured in Bunnell's Museum in 1874. According to a playbill in the Harvard Theatre Collection, Bismarck would "cast the horoscope of the future for the ladies, telling their fortunes by cards," and would play various games of cards, including euchre, seven-up, and poker, "beating the most expert and ablest card player." This exacting repertoire corresponds closely to the one recorded in Bismarck's volume.

George Middleton, the circus and dime-museum magnate, also exhibited a pig called Bismarck in South America, probably in the 1880s. This outraged a group of prominent German citizens in Montevideo, who thought so much of their own Bismarck that they could not tolerate this association with a hog. Middleton replied that the pig was as wonderful, in his own way, as the great German leader. Middleton refused to rename his "pig of genius."

世紀末

奇芸談

Learned Pigs & Fireproof Women

リッキー・ジェイ ▶著

鈴木豊雄 ▶訳

パピルス

定価 ▼ 4120円（本体4000円）

パピルス

肉体と精神を駆使した
信じがたい至芸の持主たちを
アメリカを代表する最も独創的な奇術師が語る

絶倒の書

JAPANESE TRANSLATION

LOST IN TRANSLATION, the lovely film by Sofia Coppola, had me laughing out loud. I suppose one could enjoy the movie without ever having appeared on a Tokyo talk show or being treated in a Japanese hospital, but Bill Murray's finely calibrated reaction to ordeals similar to those I personally endured made my viewing all the more engaging. And of course, this has prompted me to share some of my own adventures with you.

Toyoo Suzuki, the brave man assigned the task of rendering the convoluted prose from my book *Learned Pigs & Fireproof Women* into Japanese, was nearly lost in translation. In a section about spiritualism, I had written a sentence about "dearly departed souls shuffling off to the astral equivalent of Buffalo." Mr. Suzuki queried, "Honeymoons for the newly dead?"

On my first visit to Japan I was in the unenviable position of pinch-hitting for the greatest sleight-of-hand performer of modern times, Dai Vernon. He was scheduled to appear in Tokyo, a visit anticipated by Japanese magicians for many, many years. Vernon was then in his eighties, and just before his scheduled departure he felt unable to make the journey. I was flattered that he asked me to take his place but was faced with a dilemma: stay home and disappoint my mentor, or go and disappoint a nation.

I went, had a swell time, and was eventually invited back. For a great fan of samurai movies the highlight of this journey was a visit to the Toho film studios in Kyoto. I unfortunately arrived at closing time, but my hosts, calling on international goodwill, were able to secure us admission. We quickly fanned out over the grounds, but at that hour there was nary a samurai in sight. Finally spotting a warrior in the distance, I approached this imposing figure in his eighteenth-century garb. Sensing movement behind him, he wheeled around and regarded me disdainfully. He took a drag on his cigarette, grabbed his attaché case, and swaggered off the lot.

On another trip, I appeared on a television show with a man who was touted as "the Johnny Carson of Japan." I was booked to demonstrate my ability to throw playing cards with great accuracy and at speeds in excess of ninety miles per hour. Much like Bill Murray's character, I found myself in a situation I could not comprehend. I was on camera between the host and a renowned Japanese baseball player who just couldn't connect with my pitches or patter. It was clear they were ridiculing me, but trash talk happens when they can't hit your stuff.

During my most recent trip I was in a car on the way to NHK, the television station, with my host Ton Onoska. I felt a shooting pain. I asked the driver to pull over and I tried walking around, but no position offered relief. The throbbing became more and more intense and the car was redirected to a hospital. I howled in pain, causing many of the nurses to laugh. I am capable of profound bellowing, mind you, and I was later told that laughing and covering the face was a cultural strategy for dealing with embarrassment. Eventually a kidney stone was diagnosed and a full dose of morphine administered, just about enough for an eighty-nine-pound Japanese woman. Somehow I finally got to sleep, and awoke to find my buddy Ton-San sitting by my bed and moving strangely—almost ritually—in a rowing motion. He would clench his fists and pull them from my body toward his, with intense concentration. I asked him, "What are you doing?" "I am taking your pain," he replied. "Believe me," I said, "you don't want it." "Yes I do," he said, cementing our friendship. "I'm Japanese."

B. Killingbeck pinxt. J. Spilsbury fecit

Jedidiah Buxton

CALCULATIONS

ZERAH COLBURN, A MASTER of arithmetic computation, could count his calculating cohorts on the fingers of one hand: George Bidder, Johann Dase, Henri Mondeux, Truman Stafford, George Watson, and George Noakes.

If you were troubled by counting six rather than five names, fear not, as Zerah was born with an extra digit on both hands and both feet. It is likely this supernumerary surfeit increased his fame and helped him outshine his rivals.

Zerah Colburn, born to a poor Vermont farmer in 1804, may have been the first famous calculating child prodigy. Under the patronage of such notables as Samuel Morse, Michael Faraday, and Sir Humphrey Davies, he became for a brief time one of the most famous personalities in the English-speaking world.

Before the age of eight he was able to calculate instantly the number of seconds in 2,000 years, and the number of steps between Boston and Concord if each step was three feet long. He replied, "as fast as he could speak," 54×23; 9×138; 27×46; 3×414; 6×207; and 2×621, when asked to factor the number 1,242.

He toured the northeast (and later in Europe) with his father. At the crest of his reputation as a prodigy, one hyperbolic reviewer wrote: "The attention of the philosophical world has been lately attracted by the most singular phenomenon in the history of the human mind that perhaps ever existed." But as his precocity lost momentum, it became apparent that his talents would not produce discoveries in higher mathematics. Historian Steven Smith speculated that this resulted in an unprecedented tide of calumny. Nonetheless, Colburn led a productive life as a teacher and minister, and he authored an important autobiography of his barnstorming experiences. He died an early death in 1840.

When still a tyke, Colburn was asked by a contemptuous questioner, "How many black beans would it take to make five white ones?" He responded without hesitation, "Five if you skin them." This oft-quoted example of his quick wit reflects one of the qualities that separated him from his most famous eighteenth-century predecessor, Jedediah Buxton.

Buxton was born into a respected and well-educated family in Derbyshire in 1702. Although he exhibited a remarkable facility with numbers, he was illiterate and so unaccomplished in other areas as to be thought retarded or suffering from what today we might call savant syndrome. Nevertheless, Buxton was capable of impressive, if labored, calculations. It took him five hours to solve a problem that required a twenty-eight-digit answer, but he could give those digits forward or backward on command, and he could retain such answers for months afterward. According to a contemporary account, "He could stride over a piece of land or a field and tell you the contents almost as exact as if you measured it by the chain."

When taken to London to demonstrate his skills, he was invited to Drury Lane Theatre to see the great David Garrick as Richard III. Asked what he thought of the production, Jedediah proudly announced that 5,202 steps had been taken and 12,445 words delivered, but he had nothing to offer about plot, language, or performance.

Buxton's chief enjoyment seems to have been in the consumption of the free beer that his demonstrations frequently elicited. He combined his interests by keeping in mental perpetuity not only the running total of the 5,116 free pints but also the name of every person who bought them.

It is said that he calculated the exact date of his demise. According to legend, he "on that day bade farewell to all, went home, ate his supper, and died in his chair."

DICKENS THE MAGICIAN

CHARLES DICKENS WAS FASCINATED by wonder-workers. He described automata, dabbled in Mesmerism, and was skeptical about spiritualism. He lauded Robert-Houdin, the great French conjurer, and was fooled by Alfred de Caston, another impressive French magician. He reflected on the phantasmagoria shows of the Belgian Robertson, the stage trickery of the great English clown Grimaldi, and the exploits of the learned dog Munito. He alluded to John Henry Anderson, the Scotsman known as "The Wizard of the North," assisted the Frenchman Robin on the stage at London's Egyptian Hall, and took a group of children to see the great Austrian sleight-of-hand artist Ludwig Döbler. Dickens' play *The Haunted Man* was the first to feature the greatest theatrical illusion of the day, "Pepper's Ghost."

Dickens himself performed as a magician a number of times. On one auspicious occasion in 1849 on the Isle of Wight, according to one writer, he "studiously blackened up his face and hands, dressed himself in exotic robes that concealed a morass of 'fekes,' 'steals,' clips, pulls, and loads, tied in a gibecière, or magician's pouch, around his midriff, and appeared before an assembled company of neighbors and friends as the Unparalleled Necromancer Rhia Rhama Rhoos, educated cabalistically in the Orange Groves of Salamanca and the Ocean Caves of Alum Bay."

Fortunately, the program was recorded by his first biographer. Dickens wonderfully captured the rodomontade of conjuring broadsides of the day. He offered a series of wonders, among them: "The Leaping Card, the result of years' seclusion in the mines of Russia," "The Pyramid," for which "five thousand guineas were paid to a Chinese Mandarin who died of grief immediately after parting with the secret," and for his finale: "The Pudding," in which Dickens borrowed a hat, "of any gentleman whose head has arrived at a maturity of size," and in it cooked a plum pudding in two minutes' time, "returning the hat at last, wholly uninjured by fire, to its lawful owner." This culinary feat, the performer stated, so aroused jealousies that "when exhibited in Milan, the Necromancer had the honour to be seized and confined for five years in the fortress of that city."

It was long thought that Dickens' performance was patterned after Ramo Samee, who was the leader of a group of Indian wonder-workers featured in Great Britain in the early nineteenth century. But it is far more likely that a former member of Ramo Samee's troupe, Khia Khan Khruse, provided inspiration for Rhia Rhama Rhoos—less for his repertoire than for the epithet, as well as the distinct phraseology of his playbills.

Unlike Ramo Samee, the elusive Khruse was rarely pictured. The only portrait I have seen, actually a caricature, appeared in a delightfully illustrated children's abecedarium from 1824. The tongue-twisting title, distinctly not chosen for radio recitation, is *Aldiborontiphoskyphorniostikos, or, a round game for merry partners*.

I have long had a special fondness for Khia Khan Khruse, who, if less original, was more versatile than his former employer. I mention in the introduction to my book *Learned Pigs & Fireproof Women* that he danced on a sheet of red-hot iron, swallowed a knife that he transformed into a bell, supported a 700-pound stone on his chest (which was then broken by a sledge-hammer), fried an egg on a sheet of ordinary writing paper, and caught a pistol-fired bullet in his hand. The most remarkable thing about Khruse, I noted, was that he was not remarkable enough to warrant a chapter in my volume. Perhaps a reassessment is in order. The most remarkable thing about Khia Khan Khruse may be that he inspired one of the most celebrated writers in history.

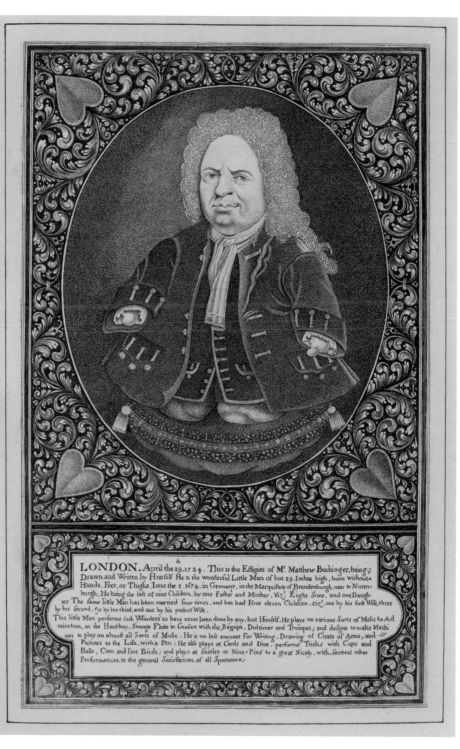

LONDON, April the 29.1724. This is the Effigies of M.ʳ Matthew Buchinger, being
Drawn and Written by Himself He is the wonderful Little Man of but 29.Inches high, born without
Hands, Feet, or Thighs, Iune the 2.1674. in Germany, in the Marquisate of Brandenburgh, near to Nuren-
burgh, He being the last of nine Children, by one Father and Mother, Viz.ᵗ Eight Sons, and one Daugh-
ter The same little Man has been married four times, and has had Issue eleven Children. Viz.ᵗ one by his first Wife, three
by his second, six by his third, and one by his present Wife.
This little Man performs such Wonders as have never been done by any, but Himself. He plays on various Sorts of Music to Ad-
miration, as the Hautboy, Strange Flute in Consort with the Bagpipe, Dulcimer and Trumpet; and designs to make Machi-
nas to play on almost all Sorts of Music. He is no less eminent for Writing, Drawing of Coats of Arms, and
Pictures to the Life, with a Pen; He also plays at Cards and Dice, performs Tricks with Cups and
Balls, Corn and live Birds; and plays at Skittles or Nine-Pins to a great Nicety, with several other
Performances, to the general Satisfaction of all Spectators.

PETER JACKSON

THERE ARE SOME WILDLY UNSAVORY aspects to the supposedly prestigious pursuit of accumulating objects of value. After all, what is a collector but someone who rationalizes why he or she above all others should own a treasure likely to give pleasure to many? And I hope you will indulge this bit of analysis from one who is a self-proclaimed master of such prevarication.

I have mentioned my fondness and respect for Robert Lund, the late proprietor of the American Museum of Magic in Marshall, Michigan, and for Rosamond Purcell, the photographer whose book *Owl's Head* is a wonderful tribute to the nobler aspects of collecting. To this pair of dignified and gracious collectors I would like to add the name of Peter Jackson.

It is generally acknowledged that Peter had the premier collection in private hands of materials on the city of London. He was a modest and unassuming fellow. It took me years to appreciate the scope of his prowess as a writer, artist, sculptor, radio broadcaster, and historian. Many of his accomplishments were completely unknown to me, until a package of tributes and obituaries appeared at my door courtesy of his widow, the noted ephemerist Valerie Harris.

I first met Peter through his neighbor, Kay Robertson, a charming woman in her seventies with tinted purple hair. She collected, with genuine zeal, modern advertising cocktail napkins: paper serviettes emblazoned with the logos of nightclubs, bars, and restaurants. But I loved to visit Kay because she had amassed a marvelous cache of materials on the great nineteenth-century clown Joey Grimaldi.

If I was surprised by the scope and depth of Kay's collection, I was flabbergasted by Peter's, only a few doors away in the quiet community of Ealing. But even more impressive than Peter's vast and accessible holdings was his intricate knowledge of the city he loved.

Walking through the streets of London with Peter transported one back in time. Every building and byway would come alive: this is the place where Chabert the poison resister first consumed prussic acid, this is the site of the exhibition of the learned dogs Fido and Bianco, here is where Bernard Cavanagh was incarcerated during his voluntary fast on Lamb's Conduit Street in 1841.

Of all my encounters with Peter, I think the most memorable took place not long after my first visit to his home. I had discovered that Peter and I shared a passionate interest in Matthew Buchinger, the Little Man of Nuremberg, the armless and legless calligrapher and magician who was then and is now the focal point of my writings about unusual entertainers. Among Peter's treasures were a number of original Buchinger items, including the superb stipple engraving from 1724 of a drawing by and of the Little Man in which, concealed in the curls of his wig, were micrographic renderings of seven psalms and the Lord's Prayer.

Peter had a duplicate of this splendid print, and I mustered all my courage to ask if he might be interested in a trade. He graciously said that he would be happy to let it go for an equivalent piece of Londoniana that he did not possess. Over the next year I wrote a number of times, wary of pestering him, but ever so anxious to consummate the transaction. Although I kept offering what I thought were rarities, I never found an item he did not possess.

Some months later, on a particularly cheerless day at a particularly cheerless time in my life, I opened an unmarked package. It contained the engraving of Buchinger, and a note from Peter saying that he believed that the Little Man was destined to reside in my home.

To this day, whenever I look at that print of Matthew Buchinger, I think not only of the Little Man, but of Peter Jackson.

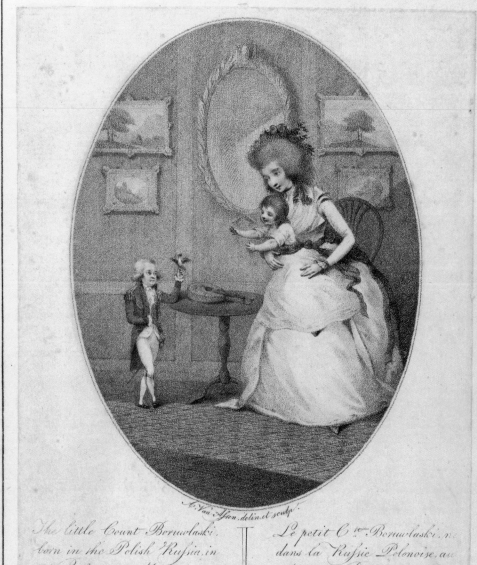

J. Van Assen delin et sculp.

The little Count Borowlaski,
born in the Polish Russia, in
November 1739. Married in
1780. He has three Children:
his Size is like that of a
Child 3 or 4 Years old.

Le petit Cte. Borowlaski, né
dans la Russie Polonoise, au
Mois de Novembre 1739. Marié
en 1780. Il a 3. Enfans, Sa Taille
et Come Cille d'un Enfant de
3. a 4. Ans.

Published as the Act directs May 12 1788 by Borowlaski No 162 Corner of Strand Lane.

WAGERING ON THE INEVITABLE

INSURANCE IS A BETTING GAME. Life insurance is wagering on the inevitable. We know what will happen, we just don't know when…

Notwithstanding the indiscretion, members of White's, the eighteenth-century London men's club, would stake substantial sums on the deaths of individuals. These speculations were privately recorded in their infamous Betting Book. In 1754, Lord Mountfort wagered Sir John Bland one hundred guineas that the grand impresario of Bath, Beau Nash, would outlive the poet laureate Colley Cibber. The Betting Book, however, attests that Lord Mountfort and Sir John both died before Cibber and Nash did, and both by their own hand. Lord Mountfort's suicide may have been precipitated by the sudden loss of income when yet other men, who provided him handsome annuities, had the gall to predecease him, and did so on the same day.

A contemporary of these wagering fools was Count Joseph Boruwlaski, "The Celebrated Polish Dwarf." To posterity he was as well known for the annuity on his life as for his diminutive size. He was born in 1739, not actually a count, but an untitled member of the Polish nobility. Boruwlaski was educated, witty, and splendidly well formed. John Timbs called him "a perfect copy of nature's finest work in duodecimo."

Early in life he received noble patronage, but in young adulthood he made a love match not to the liking of his patron, and this support was withdrawn. Although he was compelled to exhibit himself for money, elaborate charades were enacted to preserve the count's dignity. He concertized on the guitar for a modest fee, and appeared in residences where his gratuity was diverted to his valet.

Boruwlaski wrote a popular autobiography that was often republished, and he was the subject of numerous portraits. He enjoyed the company of Voltaire, Sir Walter Scott, and the esteemed actor Charles Mathews; he was coddled by the Empress Maria Theresa and received a ring from Marie Antoinette. He was bounced on the knee of King George IV, but this must be considered a dubious distinction as he was then in his eighties. Indeed, it was his age that was to become his most surprising attribute.

Twenty-some years ago I purchased a holograph manuscript of the count's autobiography. It was a presentation copy that he prepared for the Metcalfe family, his major benefactors. Tipped into the book was a document that related the details of an annuity.

In June 1805 it was agreed that a policy of forty pounds be raised for the count, who was then sixty-six years of age, to spare him "the painful necessity of exhibiting himself for money." Miss Metcalfe, who acted as group treasurer, anticipated that the pool of contributors would inevitably contract and collected extra funds at the outset. The money unfortunately did not last long enough for the count. At Metcalfe's demise in 1824, only twelve of the original fifty-six subscribers were still alive, and "the fund was completely exhausted."

The biography of Charles Mathews reveals that a wealthy tradesman also sold the elderly midget an annuity. As life expectancy was then shorter, and lives of dwarfs shorter still, this seemed a prudent wager. Yet the investment did not pay off. While the tradesman grew older and increasingly infirm, the count, appearing almost eternally youthful, survived and thrived.

When Boruwlaski finally died, in 1837, he was in his ninety-ninth year. He was eulogized with this quatrain:

A Spirit brave, yet gentle, has dwelt, as it appears,
Within three feet of flesh for near one hundred years;
Which causes wonder, like his constitution, strong
That one so short alive, should be alive so long.

COMING!

PROF. THEO. PULL

America's Foremost

Hypnotist, Mind Reader, Illusionist and Company of High-Class European Vaudeville Stars

The Most Wonderful Performance Ever Presented on the American Stage.

Highest Satisfaction Guaranteed

Refined and Scientific

A Ladies' Performance

Moderate Prices

The Eminent Authority on Occult Sciences

Many Imitators No Equals

CLEAN AND DIRTY

Having limited intercourse with today's youth, I don't know if maledicta-muttering children still have their mouths washed out with soap.

Soap has long been a tool of the nefarious. One of the oldest books in my library, *Liber Vagatorum, The Book of Vagabonds and Beggars*, speaks of swindling mendicants who "fall down before the churches, or in other places with a piece of soap in their mouths, whereby the foam rises as big as a fist…as though they had the falling-sickness." These Grantners, as they were called, were feigning the malady we now call epilepsy. "This is utter knavery," the passage continues, "there are villainous vagrants that infest all countries."

The Book of Vagabonds and Beggars, published in the first decade of the sixteenth century in Germany, was one of many early sources for this unexpected union of the clean and the dirty. The universality of the ruse may seem surprising, but good news travels fast. The scam is described in almost identical form in *The Workes of that Famous Chirurgon, Ambrose Parey*, from sixteenth-century France. In *Il Vagabondo*, the famous early Italian work on beggars, Giancito Nobli spoke of "accadenti" who feigned epilepsy.

Thomas Dekker, in *The Belman of London* of 1608, described beggars who "to cause that foaming in their mouthes, (which is fearful to behold by the standersby)… have this trick, privately convey a peece of white soape into one corner of their Jawes, which causeth the froth to come boyling forth."

A half-century earlier Thomas Harman classified such men as Counterfeit Cranks, masters of deceit, who prefer to go "halfe naked, and looke most pitiously," and "never go without a peece of white sope about them, which, if they see cause or present gaine, they will privetly convey the same into their mouth…and marvelously for a time torment them selves; and thus deceive the common people, and gaine much."

Soap eaters have also perpetrated theatrical fraud. The mind reader Theodore Pull feigned a trance and foamed at the mouth to add dramatic verisimilitude to his performance of pseudo-telepathy.

Soap had other illicit uses. Early in the sixteenth century unscrupulous gamesters rubbed certain playing cards with soap in order to locate them more easily in the course of dealing or cutting the pack.

"Soapy" Smith, the famous card hustler and confidence man, derived his moniker from a street pitch in which he sold cakes of soap wrapped in paper. As a come-on, Soapy would enclose large denomination bills in some of the packages. He would mix these bars among the others and then hawk them all at a steep price. Not surprisingly, the soap with the prize money was invariably purchased by his confederates.

One of the most famous soap scams is attributed to the notorious John Dillinger. It is widely believed that he fashioned a gun from a bar of soap, blackened it with shoe polish, and used it to effect his release from Crown Point Prison in 1934. This, I must reveal, is apocryphal. Dillinger escaped using a gun carved from wood. Two members of Dillinger's mob, however, hearing of this trick, used soap guns for an attempted escape from an Ohio prison.

The ploy was wonderfully parodied in the film *Take the Money and Run*: a rainstorm causes the pistol in Woody Allen's hand to lather and foam.

In the film *House of Games* a con man tries to intimidate a victim with a very realistic water pistol. As the gun drips, Lindsay Crouse says to the hapless criminal, "You can't threaten someone with a squirt gun." The actor, who replies that he couldn't very well threaten someone with an empty gun, was, I sheepishly confess… me.

INDIAN CONJURING

BY

Major L.H. BRANSON

INDIAN ARMY

With an offer of

£ 300-0-0

REWARD

LIAR'S LARIAT

ON APRIL 16, 1890, the *Chicago Tribune* published an account of what is arguably the most famous illusion in the long history of conjuring. The reporter, John Elbert Wilkie, wrote of two Yale men who while traveling in India witnessed the performance of a Hindu fakir.

In an open field, with nary a stage or magician's apparatus in sight, the mystic hurled a coil of twine into the air where it unwound and remained suspended. At the fakir's request a young boy climbed up the now-rigid rope and reached a height where he was no longer visible. He disappeared into thin air.

As the *Tribune* went on to report, the Yale men then exposed the secret of the classic Indian rope trick. One fellow sketched the illusion as he witnessed it; the other, a keen amateur photographer, took pictures with his early Kodak. The drawings confirmed the verbal description, but the snapshots revealed only the conjurer sitting on the ground. There was no twine and no child. Wilkie concluded, "Mr. Fakir had simply hypnotized the entire crowd, but he couldn't hypnotize the camera."

The story spread like wildfire in the American press and throughout Europe. Four months later, the *Chicago Tribune* printed a complete retraction: the Yale men did not exist, there had been neither a rope trick nor a mass hypnosis. Wilkie's article, which had enthralled readers by claiming to expose an illusion, was itself a hoax.

Peter Lamont tells this story in his swell book, *The Rise of the Indian Rope Trick*. He entertainingly and persuasively argues that the legendary illusion is a modern fable based on Wilkie's article of 1890.

After reading of the Rope Trick many travelers purported to have witnessed the performance personally, but their recollections did not hold up to scrutiny. Even the long-dormant magical narratives of Marco Polo and Ibn Batuta became subject to revisionist interpretations.

As Lamont recounts, the *Tribune*'s retraction could not stem the tide of notoriety caused by the original story. It became an indefatigable parable of cross-cultural encounter. Madame Blavatsky, the mystic and founder of the Theosophic movement, claimed to have seen the trick performed in Egypt. Erik Jan Hanussen, the Jewish-born mentalist who became Hitler's "clairvoyant," said he witnessed it on the site of ancient Babylon. Robert Benchley, the humorist, offered irreverent speculations.

The premier American prestidigitator, Harry Kellar, ascribed the Rope Trick to hallucinations induced by hashish. Famous magicians including John Nevil Maskelyne debunked the effect, or offered large cash rewards to see it performed. These conjurers feared that if the tales of the Indian Rope Trick were believed, their own Western magic would pale in comparison. Many created versions of the Rope Trick in their stage shows, set in modern, well-equipped theaters, but these presentations had less appeal than an imagined miracle in an exotic Indian bazaar.

How do we distinguish between a hoax and a con? Perhaps it is simply a matter of intent. If a hoax is mischievous and a con malicious, where do we place journalists like John Elbert Wilkie, whose story on the Rope Trick was a salvo in the Chicago newspaper wars? More alarmingly, what does the scale of Wilkie's success presage for the future careers of fabricators like Jayson Blair at the *New York Times* and Stephen Glass at *The New Republic*?

Wilkie stayed on at the *Tribune* and won fame as an intrepid crime reporter. While serving as city editor in 1898, he was summoned by the Secretary of the Treasury. Because of his diligence, tenacity, and reputation for "perfect honesty," he was offered, and accepted, the position of Chief of the United States Secret Service.

In the Great Room, at the *Rose and Crown, Kew-Green,*

This present THURSDAY, *July* 30, 1795,

Door to be open at Seven, the Operations begin at Half past Seven.

PIT TWO SHILLINGS,——GALLERY ONE SHILLING Only.

The Sieur BOAZ,

Will add to his amazing Operations! the following Particulars;

Which he had the Honour to Exhibit, on the 2nd of November, 1772, to their Majesties and all the Royal Family, the Prince of Mecklenburgh, the Russian Ambassador, &c. in the Palace of Richmond, and for which he was presented with a Fifty Pound Bank Note.

PART I.

He will Exhibit many new and astonishing

CARD DECEPTIONS,

And particularly an EXPERIMENT *on*

MAGICAL and SYMPATHETIC WATCHES,

The like never before attempted in this Kingdom.

PART II.

An Operation in Papiromance;

By which means Mr. BOAZ will discover the real Thoughts of any Person in Company, without asking a single Question; and, however impossible it may appear, he will communicate the Thoughts of one Person to another without the Assistance of Speech or Writing.

PART III.

The Teritœpiest Painter.

This most astonishing and pleasing Operation is performed by Means of an invisible Agent; who will, in presence of the Company, in less than Two Minutes, copy in Miniature any Painting proposed by any one present, without Mr. Boaz being told what Painting is to be delineated, or even his being in the Room.

PART IV. A VARIETY OF

UNCOMMON EXPERIMENTS,

Never Exhibited here before.

THE WHOLE TO CONCLUDE WITH

A Grand Meloskelothermick,

And which is as follows, viz.

Six or Eight Ladies may each fix their Thoughts on different Cards, and the Cards so thought on will be found in and cut out of

A Roasted LEG of MUTTON,

Which will be brought upon the Table Hot from the Fire,

To the astonishment of every Beholder!

HANDS

THE TOOLS OF MY TRADE, as a conjurer, are my hands.

I have looked after them most of the time with the care that such professional equipment deserves, but I doubt that my concern could be called obsessive. I have never had a manicure. Unlike some pianists, I allow other people, often total strangers, to grasp them heartily and shake them. Worse still, I must confess that in my martial arts phase I even broke boards and bricks with them, proving that I am both dumber and luckier than I usually acknowledge. This is a story about hands and tools.

As I recounted in my book *Learned Pigs & Fireproof Women*, I enrolled many years ago in the Cornell University School of Hotel and Restaurant Management. A callow youth, I vaguely hoped to combine the talents of the cooking and gaming tables, which I naively believed would uniquely qualify me to manage a Las Vegas casino. Failing that, I thought I might be able to duplicate the culinary magic of Sieur Herman Boaz, who in 1795 invited eight ladies to fix their thoughts on different cards, "the cards so thought of, were found in, and cut out of, a hot Roasted Leg of Mutton."

I soon found myself in the cooking lab of the doyen of the hotel school, a massive and imposing man, all too fond of bellowing, "Why do we eat meat?" The professor would then fold his hands and cast his eyes around the room as if challenging us to retort, so that he could pounce on, mix, mash, blend, and puree the hapless heckler.

On the first day of class he instructed us to preheat our ovens and listen attentively to his lecture. Circumspectly watching the others, I quickly learned the secret of igniting the appliance. Having never so much as fried an egg or prompted the ejaculation of my own toast, I was fascinated.

The lecture over, we were told to commence cooking. Our first project was to prepare bacon by broiling it on a rack over a drip tray. Immediately, I opened my oven and grasped the top rack between my thumb and forefinger. For years thereafter, the sound of the sizzle and the brand of the word AJAX on my digit were reminders of my all too literal acceptance of instruction: the stigmata of blind faith.

As my car radio served up Bob Dylan crooning "Tweedledum and Tweedledee" from his album *Love and Theft*, I was reminded of my losing joust with the convection oven.

Some time ago I was asked to participate in a video production of that very song. The chosen setting was a card game. Dylan, who just may have the world's greatest poker face, was joined by two women—who in the context of this clip might appropriately be called broads—the formidable Eddie Gorodetsky flashing his diamond studded tooth, and myself as the nefarious dealer. After finishing on Dylan, the camera "turned around" onto me. A grip climbed up to adjust a light some eight feet over my head, and while he was so engaged a screwdriver fell from his tool belt. It descended blade first and struck my outstretched hand, just below the knuckle of my left little finger. The room went silent for a moment and then the entire cast and crew rushed to my side. They offered everything short of a ride to the hospital before my segment was finished. I successfully completed my work and was escorted to the doctor. In a narrow digital escape I was uninjured, although I did leave his office with a cast… on my foot. I'd explain, but that, as they say, is another story.

MONSTER

CHARLIZE THERON'S PORTRAYAL of a serial killer in the film *Monster* elicited my greatest admiration, not that my panegyric was paramount, as she garnered a few other accolades, including the Academy Award, for her performance.

I would be remiss, however, if I failed to report that the film transported me from the disturbing circumstances of its real-life protagonist, Aileen Wuornos, who brutally killed seven men, to a notorious series of attacks on the streets of London two hundred years earlier.

The perpetrator was known as "The Monster." His mode of attack, sexually motivated like Wuornos', was to accost women with foul language and then stab their clothing, usually around their buttocks. He occasionally penetrated his victim's skin, but he never came close to inflicting a mortal wound.

The Monster was believed to be an ex–dancing master turned artificial flower–maker named Renwick Williams. He created more widespread panic than Wuornos ever did, even though his victims invariably survived. Near-hysteria reigned on the streets of London. Large cash rewards were offered for information leading to the apprehension of the criminal, most posted by an insurance baron who was often accused of prurience in his solicitousness for the assaulted women. An inadequate police force was pressured to find a suspect. False arrests followed accusations by those eager to collect the reward money. Copycat crimes were enacted. Some women were accused of fabricating assaults. Opportunists claiming to be victims were sometimes found to be pickpockets who had divested their gallant would-be rescuers of their purses.

Eighteenth-century women who could endure the rigors of fashionable undergarments found themselves mercifully protected. Whalebone stays and cork rumps that tortured the torso and extended the line of a dress impeded many a wound. Even women who were already slaves to fashion were encouraged to outfit themselves with buttock-protecting body armor. A copper cuirass was the favorite of women of means, while porridge pots were affixed under the clothing of less wealthy if no less frightened females. An apple in the pocket of one victim absorbed the blow like a bullet-thwarting Bible that has saved the life of many a movie protagonist. The incident inspired this ditty:

> *The Apple was, in days of yore,*
> *An Agent to the Devil,*
> *When Eve was tempted to explore*
> *The sense of Good and Evil*
>
> *But present Chronicles can give*
> *An instance quite uncommon,*
> *How that which ruin'd mother Eve*
> *Hath sav'd a modern woman.*

Renwick Williams was apprehended and put on trial in 1790 with Judge Francis Buller presiding. Buller, far from a bulwark of justice, had earned the epithet "Judge Thumb" for his prior ruling that "any man could thrash his wife with impunity provided that the stick [he wielded] was no thicker than his thumb."

In the proceedings, the Monster's foul language was subjected to nearly as much opprobrium as the stabbing. Judge Buller took particular offense at an expression with which Williams was said to accost his victims, calling it "vulgar and distasteful…truly befitting a Monster." The phrase, which I am loathe to repeat, was, "Oh, Ho! Is that you?"

Theatre Royal, Covent Garden,

HIS MAJESTY

Having been pleased most graciously to Command, that His BOX should
be prepared for the Reception of those ILLUSTRIOUS VISITORS, the

King and Queen

OF THE

Sandwich ISLANDS,

The Publick is most respectfully informed, that they will honour THIS
THEATRE with their Presence

This Evening, MONDAY, May 31, 1824,

When will be performed the Tragick Play of

PIZARRO.

PERUVIANS.

Ataliba, Mr. EGERTON.

Rolla, - - Mr. YOUNG,

Fernando, Miss VEDY, Orozembo, Mr. CHAPMAN, Hualpa, Mr. BLANCHARD,
Topar, Master LONGHURST, Huscah, Mr. NORRIS.
Orano, Mr. MEARS, Harin, Mr HEATH, Capal, Mr SUTTON, Rama, Mr. COLLET,
Cora, Miss LACY.

Priests, Virgins, Matrons, in

THE TEMPLE OF THE SUN.

High Priest, Mr. TAYLOR,

SPANIARDS.

Pizarro, Mr BENNETT, Alonzo, Mr. ABBOTT,
Las Casas, Mr. EVANS, Almagro Mr. HORREBOW, Davila, Mr. PARSLOE,
Gouzalo, Mr. ATKINS, Valverde, Mr CLAREMONT, Gomez, Mr RYALS, Pedro, Mr. MASON,
Sancho, Mr. LOUIS, Sentinel, Mr. RAYNER,.
Elvira, Mrs. OGILVIE.

To which will be added (for the 24th time) a

NewGrand Melo-Dramatick Egyptian Romantick Tale of Enchantment, called

THE SPIRITS

OF THE

Moon,

OR, THE

INUNDATION of the NILE.

SANDWICH

My interest in unusual entertainments has often taken me, conceptually or physically, to England, a long-standing haven for the exhibition of curious or exotic attractions. Unusual humans were often displayed: people of reduced or enlarged proportions, or who had mastered unconventional skills, or who hailed from remote corners of the globe.

Eighteenth-century Londoners had the opportunity to express this predilection by viewing American Indians, Eskimos, and South Sea Islanders. An indigenous fascination with noble lineage was generously projected onto these visiting anomalies, who were often presented as wealthy, distinguished, or singularly accomplished in their own land. Hence Omai, brought to London by Captain Cook from his second trip to the South Seas in 1775, was elevated in the press from a savage to a gentleman of considerable wealth.

In May 1824, the actual king and queen of the Sandwich Islands arrived in London to much fanfare. They were said to be seeking an alliance with England against the threat of hostile attacks on their own country. It was the Russians who were especially feared by these native Hawaiians, reported the newspapers. The journalists were unable to verify this surprising claim, as their interview with the royal couple was "encumbered by the worst-informed interpreter it ever fell to our lot to converse with."

But the journalists were undaunted, having seen plenty of exotic visitors in less official contexts. They discoursed on the royal couple's dress and physical attributes, discovered as the king and queen played whist with their entourage. The group was of the "darkest copper colour." The king and his prime minister had donned Western garb—black frock coats and silk stockings—while their female counterparts were bedizened in native *robes de chambre*, straw-colored loose-fitting garments tied with rose trim, and sported turbans of scarlet, blue, and yellow feathers. By far the most notable characteristic was their size: all the men were of stout builds and over six feet, but the women were truly prodigious, one newspaper calling them "equally fat and coarse made, and proportionately taller than the men." The queen stood six feet two.

They were received into society and the couple's social activities were well chronicled. On May 31, 1824, playbills announced that they would attend the Theatre Royal Covent Garden to witness Sheridan's *Pizarro* and a "New Grand Melo-Dramatick Egyptian Romantick Tale of Enchantment, called the Spirits of the Moon, or an Inundation of the Nile." King George IV, the bill announced, would welcome the Islanders into his private box for the performance.

It was with great chagrin that the death of Her Majesty Queen Tamehamala was reported on July 8. At this sudden and unexpected loss, the King exhibited profound sorrow, anxiety, and depression, and in spite of the intervention of England's royal physicians, less than a week later he too succumbed. Both deaths were attributed to lung ailments. The bodies were embalmed and placed in lead caskets, and lay in state in St. Martin's Church. In September, a frigate took the royal pair back to the Sandwich Islands in the company of Prime Minister Poki and the rest of the entourage.

My copy of the broadside from the Covent Garden performance has the following holograph annotation: "The playbill for their above Majesties, was, as is usual on royal visits, printed on white satin. The Queen being ignorant of its meaning, very cordially used it to wipe her nose with on several occasions, until it fell into the [orchestra] pit, where a violent scuffle ensued, as to who should bear away so delicate and precious a relic."

The Bottle Conjurers ARMS.

BOTTLE CONJURER

TELL ME IF YOU FIND THIS a hard act to swallow. A magician would borrow a cane from someone in the audience and use it to produce the sound of any known instrument. He would then ask for a common quart bottle and offer it for thorough inspection. In full view of the audience he would place himself inside the bottle. If this appeared in the "Arts and Leisure" section of the *New York Times*, would your curiosity be piqued? Do you think you would attend? Would you pay double the price of a normal Broadway ticket?

Such an advertisement did appear, but two hundred and fifty years ago, in the *London General Advertiser*. It filled a prominent theater to capacity for a very steep fee. When, thirty minutes after the appointed hour, the performer had not entered the theater, let alone the quart bottle, the crowd grew impatient, some beginning to suspect a ruse. As the management tried to calm them, a wag from the pit cried, "For twice the price the conjurer will get into a pint bottle." At this, the audience rioted and literally destroyed the Haymarket Theatre.

This event, known as the "Bottle Conjurer Hoax," is still cited as a prime example of human gullibility. It was almost certainly a perverse test of public credulity devised by the Duke of Montague. The Bottle Conjurer became ubiquitous, appearing in political cartoons and pamphlets, harlequinades and jest books. The hoax was mentioned by Charles Dickens and by Herman Melville. The Bottle Conjurer was enacted onstage by the great English clown Joey Grimaldi and caricatured by Thomas Rowlandson. Images of the man in the bottle appeared in nineteenth-century magic lantern slides, thaumatropes, trick photographs, and more recently in the circus ring and the 1995 Whitney Museum Biennial in a piece by the artist Charles Ray.

Of the slew of contemporary parodies, none was more compelling than the notices for Signor Capitello Jumpedo, who eliminated the bottle and proposed to jump down his own throat in a farce at the Drury Lane theater in London. The same day the rival Covent Garden theater announced that "Don Jumpedo, not the original, a companion to the man in the bottle, will jump down his own throat and afterwards jump up again."

In America a rare Florida playbill from 1822 announced "Felix Downjumpthroatm, the Emperor of all the Conjurers," which described the performance of five brothers: "At the conclusion of their never yet equaled feats of sleight of hand, they will each take a lighted torch in either hand, when lo! Incredible to relate: Suckee, with the burning torches, will jump clean down Mustpha's throat, who in an instant, with equal dexterity will pass down the throat of Abdullah; then Abdullah will jump down the throat of his brother Bennassar, and Bennassar, down that of Muley's; who lastly, notwithstanding he is encumbered with his four brothers and their four torches, will throw a flip flap somerset down his own throat and leave the audience in total darkness!"

The brothers' voluntary ingestion was in stark contrast to a racist playbill from 1870 mocking the recently passed Fifteenth Amendment. This program concluded with an involuntary performance: "The celebrated feat of swallowing A Live Negro!"

A number of magic shows bordered on actual consumption. A magician would ask for a volunteer to be eaten alive. If no one came forward, the conjurer did his customary presentation, but the theater was certain to be full again the next night. If someone agreed to be eaten, here is what happened: The magician would roll up the man's sleeve and liberally season his arm with salt and pepper. The conjurer would sink his teeth into the flesh of the spectator. The volunteer would stand, scream, and run for his life.

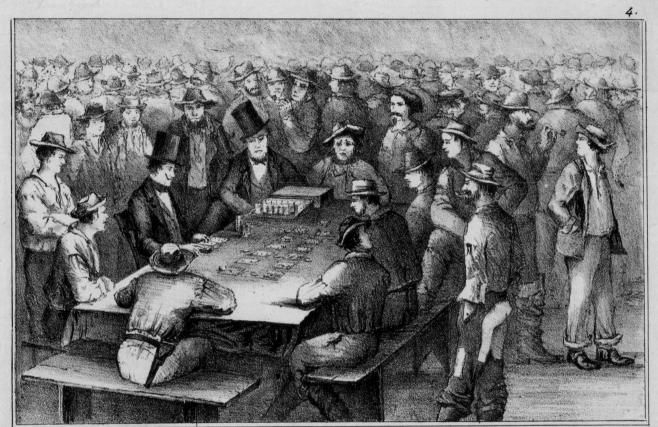

FARO.

THE DEADWOOD SPEAK

EVERY MONDAY YOU CAN FIND me in the recording studios of KCRW in Santa Monica. Every Sunday you can find me in Deadwood. In my role on the HBO show, set in the Black Hills of Dakota in 1876, I bite my tongue, I bide my time, and I watch my back.

Along with the rest of the cast and crew, I am very pleased about our enthusiastic reception. Deadwood is a tough town, though, and some of our tough talk has provoked consternation, even among our admirers.

Would a bunch of lawless reprobates in colloquy drawl in the "Howdy, ma'am" homogenized insipidity of Roy Rogers, or unleash a tirade of maledicta? Particularly when every "ma'am" in the community was more likely a "madam," or at the very least a woman of negotiable affections? We scoundrels signify, swagger, and sound off with abandon. Oaths and expletives abound, as I am sure they did in the Old West.

My shelves, rich in artifacts and indices of slang and cant, offer venerable precedents for the profane imprecations of the denizens of Deadwood. But rather than defend the linguistic choices of our chief scalawag, David Milch, who is deftly eloquent on his own behalf, I shall turn my attention to the language of wagering that you might encounter in Deadwood.

I play Eddie Sawyer, the impresario of gambling at the swank establishment known as the Bella Union, and under the picture of a black-and-orange-striped jungle cat I exhort miners to wager a bit of gold dust to "buck the tiger," as the game of faro was known.

Enormous sums were wagered on faro, the most popular card game in America before it was overtaken by poker. Players faced off against the house rather than each other. Because the odds were unusually liberal, many techniques were devised to give the bank an edge.

Dealers schemed to circumvent the major device used to insure the game's honesty, a dealing box created and patented by a Richmond gambler named Robert Bailey in 1822. It was ostensibly constructed to restrict the manipulation of the cards, an antecedent of the shoe used for blackjack or baccarat in today's casinos. The shuffled cards were placed in the metal box and drawn out by the dealer, and because the action of plucking the cards resembled the eviscerating of crayfish, the dealer was often called a gut-puller. In practice, the box spawned more subterfuge than it prevented. Resourceful and quick-handed cheaters used numerous gaffs and dodges to secure victory. As the author of the nineteenth-century classic *Faro Exposed* succinctly put it, "Dealers wear diamonds, players wear rags."

The lingo of faro was soon impressed into the language, from colloquial to standard usage: "piker," "breaking even," "in hock," "square deal," "case card," "keeping tabs," "to play both ends against the middle," and "to parlay a bet" may all have originated at the faro table. "From hock to soda," meaning from the first card in the deck to the last, was once as common as, and identical in meaning to, "from soup to nuts." The widespread use of chips or checks instead of cash is attributable to faro, as is the euphemism for dying, "cashing in one's chips."

These days I am occasionally hailed by *Deadwood* fans who greet me with a vituperative expletive that could be taken to mean a technique used to resurrect dead wood. I take no offense; I'm just playin' the hand I was dealt, tryin' not to cash in my chips before my time.

At WILDMAN's Exhibition Room,

Opposite Southampton-street, in the Strand,

By Desire of several of the Nobility and Gentry,

Mr. W I L D M A N

WILL EXHIBIT,

This and every Day, at Twelve o'Clock in the Forenoon, precisely;

And as his Stay in London will be short, he will perform at Seven every Evening, as usual.

At each Time he will display

All his amazing Performances and different Changes with the B E E S.

To which will be added, his new invented and extraordinary

DEXTERITY and DECEPTIONS,

In a most astonishing Manner,

Such as were never performed before by any other Person in this Kingdom.

Many different amazing Deceptions each Time.

The Room is warm and commodious, and will be illuminated with Wax Lights in the Evening.

FRONT SEATS Two Shillings, BACK SEATS One Shilling.

Places to be taken and Tickets to be had at the Exhibition Room.

A PRIVATE EXHIBITION may be had if desired.

N. B. *Fine Virgin Honey to be sold either in the Combs or out; also his new invented Hives, either for the Chamber or Garden, and any Quantity of Bees, from one Stock to one Hundred*

BEES

I KNOW MY LOYAL LISTENERS will find this hard to believe, but occasionally it is necessary to turn to arenas other than public radio to make ends meet.

Recently I lectured in Phoenix for a gathering of high-level managers in a tent behind a building literally, if confusingly, designated the Frank Lloyd Wright Influence House. Just before I took the stage the top executive was stung by a bee. I was momentarily inclined to change the nature of my presentation.

I began to meditate on a swarm of bees capable of inducing anaphylactic shock. What, I thought, suddenly assuming the guise of a corporate business guru, could serve as a paradigm for controlling and uniting large groups of workers in a common goal? What if the workers numbered not in the hundreds or thousands but hundreds of thousands, what if they had brains smaller than the ball of a ballpoint pen, what if each were capable of inflicting serious injury or death?

Were there examples, I pondered, of hypnotists controlling drones in the work force, or perhaps in nature? The image of a Svengali casting his powerful gaze at factory workers was compelling, but no examples were forthcoming. I then recalled, however, a surprising story from my archives of entomological entertainment.

In the 1760s and 1770s, the early days of the modern circus, a conjurer named Daniel Wildman was able to advertise to "the Ladies and Nobility" that bees would swarm among them in the air and no person would be stung by them. Wildman also allowed any spectator to cut off the head of a fowl, which he would then restore to its body, and he promised "extraordinary dexterity and deceptions" with oriental caskets, newly invented machinery, and pocket watches.

But Wildman's fame did not rest upon his mastery of illusion; indeed, in view of his other accomplishments one wonders why he performed magic. Daniel Wildman was the world's first and foremost equestrian apiarist.

In his exhibitions Wildman caused swarms of bees to move around his body from his arms to his head. With his face covered by a living bee blindfold, he lifted a glass of wine to his mouth and the bees parted, allowing him to imbibe. He willed his performers to leave their hives and alight on the sword, cane, or hat of a chosen spectator.

His most impressive stunt, however, was this: With his face covered by swarms of bees he rode the circus ring while standing on his horse, one foot on the saddle and one on the animal's neck. Signaled by a pistol shot, half the bees returned to the hive while the others marched across a nearby table.

Wildman performed for the French Academy of Science in Paris. He sold special hives of his own invention. He authored *A Complete Guide for the Management of Bees Throughout the Year*. One edition was published by Philip Astley, generally regarded as the founder of the modern circus, and for whom Wildman occasionally performed. It bears the curious note: "Also, sold by Mrs. Astley, so well known for her great Command over the Bees."

It is likely that Wildman taught her his act. Other imitators did not receive his sanction, although one even assumed his name in an attempt to capitalize on Wildman's celebrity.

A contemporary poetic tribute reads:

> *He with uncommon art and matchless skill,*
> *Commands those insects, who obey his will;*
> *With bees others cruel means employ,*
> *They take the honey and the bees destroy;*
> *Wildman humanely, with ingenious ease,*
> *He takes the honey, but preserves the bees.*

TRAINED FLEAS
Now Showing at HUBERT'S MUSEUM
228-232 West 42nd Street New York City

TIMES SQUARE

TIMES SQUARE TURNED ONE HUNDRED a few years ago, and while I have never been keen on birthdays, I am fond of Times Square and fond of centenarians. I have been gathering material for a book to be called *100*, a pictorial history of long-lived folk whose age engendered celebrity and consequently celebratory portraits. Combing through the engravings in my collection from as far back as the seventeenth century, I have managed to locate only eighty-seven appropriate prints and wonder if I shall reach the requisite total of one hundred before my own number comes up.

There is something grand about centenaries. Perhaps I like them because they allow us to consider a temporal range beyond our own life span and make us wonder where we fit in the continuum.

Times Square was the focal point of my show *Ricky Jay: On the Stem*, a personal homage to old Broadway. I discoursed on the wiles of hustlers and spivs, journalists and poets, showmen and charlatans, as a background to my performance of sleight of hand.

Our theater was in the heart of their stomping grounds at 43rd and Eighth Avenue. One of our first shows was a charity fundraiser that included a celebration at the newly opened Madame Tussauds Wax Museum at 234 West 42nd Street.

If Tussauds was new to Times Square, it was nonetheless a venerable institution whose combination of popular entertainment, fickle fame, and the artisan's work in polychromatic wax seemed an inevitable part of the street. Standing in Tussauds, I realized I was on the exact site of Hubert's Museum, that much heralded and much maligned monument of Times Square.

Hubert's opened its doors in 1925. It was home to a fascinating assortment of characters, particularly those physical anomalies labeled "freaks."

This Times Square ten-in-one captured the attention of a disparate group of artists: the great *New Yorker* writers A.J. Liebling and Joe Mitchell, the critics Robert Garland and George Jean Nathan, the photographer Diane Arbus. Lenny Bruce, Bob Dylan, and numerous other worthies have shown us its lures and charms.

The major attraction of Hubert's, almost from its inception, was William Heckler's Trained Flea Circus. As a boy, already completely engaged by the world of variety entertainment, I went to Hubert's to take in Congo the Wild Man, Sealo the Seal-Finned Boy, and Harold Smith on musical glasses, but mostly I went to see Presto, a gifted conjurer, and to witness Roy Heckler, William's son, put real live fleas through their paces.

Abraham Lincoln said that running the country was like shoveling fleas across a doorway; at Heckler's the fleas did the shoveling, and a lot more. Roy Heckler presented almost the same show his father had many years earlier. Though Hubert's Museum closed its doors in 1965 I still recall almost verbatim the bally of the outside talker:

"Ladies and Gentleman, downstairs you'll meet Professor Roy Heckler's world-famous trained flea circus. Sixteen fleas, that's six principals and ten understudies, and they will perform six different acts. As act number one a flea will juggle a ball while lying on its back. As act number two, a flea will rotate a tiny miniature merry-go-round. As act number three, three fleas will be placed on chariots and the flea that hops the fastest will, of course, win the race. But the act, ladies and gentlemen, that most people talk about, the one they pay to see, three tiny fleas will be put in costumes and placed upon the ballroom floor and when the music is turned on those fleas will dance. I know that sounds hard to believe, but may I remind you that seeing is believing, and you'll see it all on the inside in Professor Roy Heckler's trained flea circus."

MODEL PRISONER

MY FATHER ONCE GAVE ME a model airplane in a futile attempt to bond. It was soon clear that whatever interests and skills I had lay in another direction. Had he purchased instead a book about model makers he might have laid the groundwork for some calculated camaraderie. The monograph I had in mind was *The Life of the Ingenious Agricultural Labourer, James Anderton; The Founder and Builder of the Model of Lincoln Cathedral…Made from One Million Eight Hundred Old Bottle Corks*.

This homage to an uneducated farm worker was published in Newcastle in 1868. The replica of the Lincoln Cathedral, which was ten feet in length and almost six feet high, took more than ten years to complete. The author noted that if James Anderton were ever to achieve some heraldic distinction, his motto would be "Patience, Perseverance and Industry." Anderton, the son of poverty-stricken parents, soon began to exhibit his model for donations. At first, outfitted in a black suit purchased by a wealthy uncle, he looked too prosperous and received almost no money. It was suggested that he don instead the dirty garments that he wore while carving, and over these he placed the even grimier smock of the field worker. This transformed his fortune as a busker and he was able to secure a living presenting these marvels of cork construction.

This project seems to me distinctly different in spirit and accomplishment from the recent replica of the Basilica at St. Peter's in Rome, assembled by a whole slew of charity workers using ten million soda pop cans.

The exhibition of cork houses of worship long pre-dated Anderton's cathedral. In the late eighteenth century Richard Dubourg displayed impressive cork sculpture in London. His model of Mt. Vesuvius, complete with flowing lava, however, was destroyed by its own special effects.

The exhibition of miniature edifices has been traced to the fourteenth century. Among the early presentations were paper models of churches, turrets composed of enameled porcelain, and a five-foot-tall tower of cards, "neither sew'd, stich'd nor pasted." I first became aware of these exhibitors from an edict of the seventeenth century that grouped model makers with acrobats, minstrels, mimes, and mountebanks.

One early reference tells of an exhibition of moveable figures fashioned from beef bones. These marrowed mannequins were carved by convicts. If the inmate has the requisite skills, prison can provide an abundance of time to commune with the muse.

Today, remarkable prison pieces, often likened to "outsider art," are extolled, exhibited, and sold for substantial prices. Among my current prison-made favorites are exquisitely detailed diminutive chairs carved from Ivory soap and tiny tapestries "woven from disassembled socks."

In the film of Nelson Algren's *Man With a Golden Arm*, Frank Sinatra plays the drug-hooked hustler Frankie Machine. On being released from prison, Frankie presents his wife with a belt meticulously shaped from woven cigarette packs. As Algren says:

> *"It's all in the wrist with a deck or a cue.*
> *And Frankie Machine had the touch*
> *He had the touch and a golden arm."*

A prisoner friend of mine with a "golden touch" constructed a series of miniature magic props fashioned from toothpicks. This was his great escape. He assembled each original figure with Elmer's Glue, using only a nail clipper to cut and plane each timber. He fabricated more than thirty illusions, including a faithful replica of "sawing a woman in half." It is, like all his creations, fully functional, assuming you can find a suitably proportioned woman. In an odd twist of fate, his sentence ended just days before the completion of his last matchstick model, Houdini's "Walking Through a Brick Wall."

LES RATS QUADRILLES,
(The Rats.)

COMPOSED
by
G. REDLER

LONDON
PUBLISHED BY C. SHEARD, MUSICAL BOUQUET OFFICE, 192, HIGH HOLBORN,

CITY WHOLESALE AGENTS. E. W. ALLEN, 11 AVE MARIA LANE. and F. PITMAN, 20, PATERNOSTER ROW.

MUSICAL BOUQUET.

RAT PATROL

A STORY IN THE *New York Times* extolled the virtues of the Gambian giant pouched rat. A leashed rodent posed for the accompanying front-page photo, and he was, dare I say it… debonair.

Why, you might well ask, did this fellow deserve such accolades?

Denizens of Sub-Saharan Africa, he and his mates are bred in Tanzania and shipped to Mozambique, where they are trained for the formidable task of detecting land mines. The article extolled their virtues: they are plentiful, they have a superb sense of smell, they are easy to transport, they immediately master tasks linked to the reward of nuts or bananas—and even though they are the world's largest rats, ranging between two and six pounds, they are too light to detonate the mines.

While this may be the most useful job ever assigned to a rat, it is far from the most engaging. There is a long history of rats training for the stage, and some performers have achieved considerable renown.

In 1867, one of the most attractive outdoor shows in Paris was said to be the exhibition of the trained rats of Antoine Leonard in Montparnasse.

A vaudeville staple was "Swain's Cats and Rats," in which these natural enemies not only coexisted but even cavorted on a miniature track. Mounted on the cats, the rats were resplendent in racing silks and jodhpurs.

Groucho Marx once appeared on a bill with both Swain and the great Fanny Brice. Fanny screamed when a rat, clearly not dressed for the track or paying AGVA dues, scurried across her dressing room floor. Swain was called to the rescue. Ignoring Brice, who was standing on a chair with her skirts hiked up, he wielded a Turkish towel and captured the intruder. The next time the Marx Brothers performed with Swain, the show's finale featured the newly recruited rodent carrying the American flag.

Fred Allen, whose fame as a comedian rivaled Groucho's, told the same story, only in his version it was not Swain but Nelson's Cats and Rats who presented the turn. "Nelson's Boxing Cats" was another well-established vaudeville favorite, but as I can find no record that Nelson worked with rats, I am inclined to endorse Groucho's version of the story.

In *Forging His Own Chains*, the memoir of George Bidwell, a nineteenth-century financial hustler who defrauded the Bank of England, he told of befriending rats and mice during his prison confinement. He taught a mouse to lie on his open hand with feet in the air as if dead, and upon command to revive from this apparent rigor mortis, scamper up his arm, and dive into his shirt. He fashioned a trapeze out of a pencil wrapped in twine and suspended by yarn. His prize rat did revolutions on the bar, rivaling the modern stars of the Cirque du Soleil. George's brother Austin Bidwell, a co-conspirator, told exactly the same story in his autobiography, *From Wall Street to Newgate, Via the Primrose Way*. The Bidwells evidently found a fresh scam, each publishing essentially the same memoir under different titles.

An impressive exhibition of trained rats was presented in France at the famous St. Germain Fair in the middle of the seventeenth century. According to an early description, a featured performer stood upright with its hind legs grasping a rope and made tiny forward and backward steps like a whiskered Wallenda. A troupe of eight executed dainty movements on a table to the accompaniment of violins, with "the elegance of professional dancers." The star performer, however, was a white rat from Laponie who "danced a saraband with such aplomb and grace" that he could have delighted Louis XIV himself.

MONSTROUS CRAWS, at a New Coalition Feast.

Pub.ᵈ May 29ᵗʰ 1787. by S.W.Fores, Piccadilly.

STUCK IN MY CRAW

AMONG THE MORE ANOMALOUS attractions in an age of anomalous attractions was a trio known as "The Monstrous Craws." In the 1780s, they journeyed to London from an unnamed locale in South America. They were distinguished physically by their small stature (they were under four feet tall) and by the unusual excrescences that extended from their chins like a pelican's pouch. These goiters, indicative of some thyroid disorder, prompted their billing as "The Monstrous Craws."

They were shown at Mr. Beckett's shop in the Haymarket. Beckett, a trunk maker, was so fond of atypical attractions that he also featured at various times a learned goose, a man who ate only stones, and a woman who was said to be pregnant continuously for six and one-half years.

Later exhibitors claimed that the Craws were from a remote valley adjoining the Alps, and that their "age, language, and native customs are as yet unknown to all mankind." Perhaps they were precursors to a certain "King of Pop," as their skin when they were discovered was dark olive but had "astonishingly, by degrees, changed to the colour of that of Europeans."

They were exhibited to the nobility, and at Windsor Castle, and caricatured by the great James Gillray, who most unflatteringly pictured King George III with his wife and son as *The Monstrous Craws, at the New Coalition Feast*. A later caricature by the equally renowned Thomas Rowlandson depicted only a single Craw.

The Craws were usually described as two women and a man, but some sources stipulated two men and a woman. That was the configuration presented at the Royal Circus under the direction of Charles Hughes.

One night in October 1787, they were missing from their quarters. The subsequent account of their kidnapping elicited not only moral outrage but also a revelation of their considerable earning power. On October 20 Hughes reported: "The Craws having early this morning made their escape from the set of villains, who had forcibly taken them from their apartments at the Circus, during the night of the 16th they are again returned to him to implore his protection from the wretches, who not content with realizing immense sums by them, in a free country, wished to treat and confine rational Human Beings like mere brute beasts, as they had done before with impunity, and in defiance of the law." Hughes proudly announced their reinstatement at the circus and promised that "the Female Craw, particularly, will perform several feats on one, two and three Horses."

I have always been partial to anomalies that performed rather than merely exhibited in silent tableaux. For example, while I am fascinated by Siamese twins, I am especially fond of the Bohemian sisters Rosa and Josefa Blazek who, joined at the hip, entertained by playing duets on violins. Hence my excitement upon learning of the equestrian accomplishments of the female craw.

This poem, "The Monstrous Craw on Horseback at the Royal Circus," appeared shortly after the kidnapping:

> As novelty pleases the great and the small,
> A new exhibition attention must call;
> The Monstrous Craw will the matter decide
> At the Circus each night she on horseback will ride.
>
> She will gallop and trot as the Horse keeps its pace,
> And ride like a Craw with a monstrous gate;
> To please every fancy, if one will not do,
> She will mount up again, and will ride upon two.
>
> To say any more wou'd be vain and absurd;
> If you see, you'll believe, and will then take my word;
> To see and believe is a very old law,
> And this will be prov'd by the Monstrous Craw.

MAJOR JAMES GEORGE SEMPLE LISLE

Pub.ᵈ September 1 17.99. by W. Stewart 194 Piccadilly

MAJOR SEMPLE

I WAS RECENTLY INVITED TO LEND my imprimatur to a series of reprint biographies of twentieth-century con men. I have always been more intrigued by their eighteenth-century predecessors, obscure practitioners who long predated the term "confidence man."

I alighted on the anonymous biography of a British rogue called Major James George Semple. It was published in 1786 and titled *Memoirs of the Northern Impostor or Prince of Swindlers*.

Today's stories of corporate connivers make Semple's deeds sound tame indeed. He did lay claim to a dormant title of nobility, impersonate military officers, and avoid confinement in an Australian prison, but I am most fond of the quaint pedigree the memoir assigns to the cheater as opportunist. A swindler, we are told, is "a creature begot of Downright Robbery and Dame Fortune."

Much of the modern insouciance toward swindlers and their victims can be gleaned in this story of confidence fraud: Semple was once spied in a hackney coach by two men he had scammed. They demanded restitution. Semple had the coach take the party to the home of the wealthy Lord Roydon.

Saying he would return momentarily with the funds, he left the men and was instantly admitted to the residence. After an hour the pair grew impatient and approached the imposing entryway, knocking tentatively on the door. They were told that Semple had announced himself as Roydon's relative and asked to be let out the back, as he was being pursued by unscrupulous bailiffs. Not only did the men fail to get their money, but they were also left with the coachmen's bill. Nevertheless, we are told, they "could not refrain from joining in the humor."

Semple's biography recounts notorious legal loopholes in the prosecution of swindling, and even serves up an eighteenth-century lawyer joke: A fellow was brought before the famous adjudicator Sir John Fielding for frequenting restaurants where he would purchase a basin of soup and then steal a silver tablespoon. Fielding asked the fellow's profession. "I belong to the Law, Sir." "The Law! Pshaw, damme! That's impossible," said Sir John. "If you did you would have stolen the basin too."

Semple's profession often required considerable audacity. Once, in an attempt to con a wealthy gentleman, Semple claimed to be an intimate acquaintance of the man's brother. The fellow invited Semple to dinner with the brother, who had come to town that very day. Instead of meekly retreating, Semple accepted the invitation, delighted in the free meal, and convinced the brother, a total stranger, that they had often met.

Semple was particularly adept at defrauding tradesmen: booksellers, coachmen, drapers, bootmakers, and innkeepers, before being brought to justice at last by an irate hatter.

To explain Semple's unlikely success, the compiler offers the famous anecdote of the eighteenth-century quack Dr. Rock, who one day was standing in front of his lavish offices when a real doctor happened by and interrogated him: "How comes it, that you, without education, without skill, without the least knowledge of the science are enabled to live in the style that you do? You keep your town-house, your carriage, and your country-house; whilst I, allowed to have some knowledge, have neither, and can hardly pick up a subsistence!"

"Why, look," said Rock, smiling, "how many people do you think have passed since you asked me that question?" The doctor estimated that about a hundred had crossed the busy thoroughfare. "And how many out of that hundred, think you, possess common sense?"

"Possibly one," said the doctor. "Then," said Rock, "that one comes to you; and I take care to get the other ninety-nine."

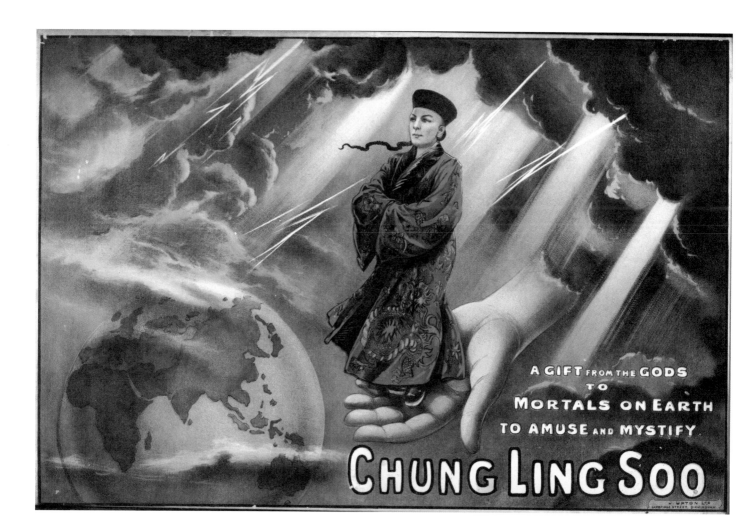

DEATH BY MISADVENTURE

CHUNG LING SOO—THE CONJURER who once billed himself as "A Gift from the Gods to Mortals on Earth to Amuse and Mystify"—prepared for the climax of his show. A spectator aimed a loaded rifle at him, and Soo steeled himself, preparing to catch the bullet in his teeth. The shot rang out in London's Wood Green Empire Theatre on March 23, 1918. Soo screamed and collapsed.

Although he had successfully performed this stunt many times before, his fall was not staged. Something was drastically wrong. He was hurried to a nearby hospital, where the next morning he was pronounced dead.

The inquest revealed these facts: Chung Ling Soo was not a "Gift from the Gods." He was not Chinese. He was an American who had assumed the identity and appearance of a Celestial. His name was William Ellsworth Robinson. He was having problems with his wife, who also appeared in the act.

Although murder or suicide was suspected, the coroner determined the events were accidental. The verdict read "death by misadventure."

This is one of the most famous tales in the history of conjuring. As a youngster I read of the many professional magicians who had been shot and killed while performing this illusion. Although I never attempted the stunt, twice I escaped death by misadventure.

Years ago I was invited to the home of a prominent German magician. Anxious to see his renowned collection of magic memorabilia, I journeyed by train to our rendezvous. He met me at the station, but on foot, and suggested I leave my baggage at the hotel he had selected and then we boarded another train to his home.

We passed up two perfectly acceptable hotels as I struggled on with three heavy bags. He had chosen a hotel far beyond my means at the time, because, as he proudly announced: "So zis is vere I have performed for your vice-president Humphrey." I was overjoyed to deposit my bags in the lobby.

At his home I was greeted cordially by his wife and graciously entertained with food, drink, and treasures from magic's past. The evening, although a memorable pleasure, strained my stamina, and the gentleman finally agreed to escort me to the local station to get the last train of the evening.

His lecture on German punctuality notwithstanding, the train failed to materialize. My host at last called his son, who was to drive me to my hotel, or so I thought… Instead I was taken to a bus stop where I boarded a vehicle—which took me to a streetcar—which finally delivered me several blocks from my hotel.

I lumbered through the deserted streets and arrived at the establishment where Hubert Humphrey once resided. In my room I tore off my clothes: my pants landed on the chair, my shirt over a lamp, and I fell instantly into bed and a deep sleep.

Some hours later I was awakened by the smell of smoke. I realized that my shirt had been ignited by the lamp. I escaped before the coroner could rule "death by misadventure."

Another near disaster awaited me in my homeland.

Back in Los Angeles, I set a pot to boil on the stove. Exhausted from my journey, I fell asleep. I was aroused by an odor so noxious it probably saved my life.

The entire house smelled like burning rubber, no doubt because I was boiling lacrosse balls. The water had completely evaporated and the balls had begun to melt and coalesce.

I often wondered what the inquest might have concluded had I not awakened. Unless the coroner was a knowledgeable juggler who knew that boiling lacrosse balls rejuvenated their bounce, his verdict would likely have read "death by misadventure."

16. Mynah
Woodcut of learned birds, probably exhibited by
J. C. Demmenie (n.p., c. 1825).

18. America's Sherlock Holmes
Photographs of Wooldridge in various disguises from *The Devil and the Grafter and How They Work Together To Deceive Swindle and Destroy Mankind* (Chicago: n.p., [1907]).

20. Tossing the Broads
Doncaster 1888: "The Scum of the Course" or The Old Sharper and his "Bonnets," colored lithograph by Tom Merry [William Mecham], *St. Stephens Review* (London, 1888).

22. Time
Engraving of Blaise Manfre by Wenceslas Hollar (n.p., n.p., 1651, 2nd state).

24. Chickens
George R. Scott, *The Art of Faking Exhibition Poultry* (London: T. W. Laurie, 1934).

26. Contrast and Compare
Mezzotint of Jaen (Hans) Worrenberg with the giant James Hansen, by Jacob Gole (n.p., n.p., c. 1689).

28. Rubber Suit
Trade Card of Paul Boyton (n.p., n.p., c. 1880s?).

30. The Cambrian Linguist
Woodcut illustration of Richard Robert[s] Jones by W. Clements (n.p., n.p., n.d).

32. Blind Faith
Engraving of Margret M'Avoy from *Kirby's Wonderful Museum and Eccentric Magazine*, vol. 2 (London: R. S. Kirby, 1820).

34. Twins
Albumen print by Stephen Berkman (New York: Bliss, Zohar Studios, n.d.).

36. Coffee House
A Catalogue of the Rarities to be seen at Don Saltero's Coffee House in Chelsea, 12th edition (London: n.p., n.d.).

38. Taking It on the Chin
Detail from hand-colored engraving, *Michael Boai the Celebrated Chin Performer with his wife and M. Engles the Violin Accompanist* (London: S. W. Fores [1830]).

40. Dirty Dick
"A Dirty Warehouse in Leadenhall Street," frontispiece to *The Eccentric and Extraordinary History of Nath. Bentley, Esq… To Which is Added the Strange and Eccentric Life and Adventures of Lord Rokeby* (London: Tegg and Castleman, c. 1803).

42. That Hamilton Woman
Emma Hamilton after George Romney; proof before text, engraving begun by Charles Broome, completed by Thomas Bragg (London: R. Lambe, 1827). For much of the nineteenth century this portrait was called *Emma Hamilton as Ariadne*; it is now thought to depict Emma Hamilton as "Absence."

44. Living Pictures
Detail from playbill of Andrew Ducrow at the Theatre-Royal (Edinburgh: n.p., 1837).

46. Misconception
A True Description of a Young Lady Born With a Pig's Face, hand-colored engraving (London: G. Smeeton, c. 1815).

48. Sharps and Flats
Smithfield Sharpers or the Countrymen Defrauded, engraving by I. K. Sherwin after painting by T. Rowlandson (London: T. Palser, c. 1787).

50. Jesus on a Tortilla
Drawing, ink and colored pencil on paper, of cartoon by David Mamet; *The Jewish Journal* (Los Angeles, 2010).

52. Reformed Gamblers
Kid Canfield The Notorious Gambler, film poster (Sydney: Swift Printing Co., [1912]).

54. Master Crotch
Engraving of Master Crotch by James Fittler (London: Mrs. Crotch, 1779)

56. Gambling with Superlatives
Frontispiece portrait from George Devol, *Forty Years a Gambler on the Mississippi* (Cincinnati: Devol & Haines, 1887).

58. Shot from a Cannon
"An Aerial Flight," colored lithographic plate from *The Children's Circus and Menagerie Picture Book* (London: Routledge, [1882]).

INDEX

❖ ❖ ❖ ❖

ACKNOWLEDGMENTS

❖ ❖ ❖ ❖

My thanks to Ruth Seymour and all the folk at KCRW in Santa Monica, including Bob Carlson, Will Lewis, Sarah Spitz, and Matt Holzman—and to my singular broadcast buddies Joe Morgenstern, Elvis Mitchell, Anne Litt, and Harry Shearer, who encouraged me to participate in these radio dramas. I am the most fortunate of fellows. I have, ask me not how, acquired access to a bright and loyal coterie of extremely knowledgeable stalwarts ready and willing to aid me with numerous and peculiar requests on a daunting variety of topics. Among these worthies I am happy to list: David Mamet, Dan Chariton, Eddie Gorodetsky, John Solt, Anne Stringfield, Rosamond & Dennis Purcell, Errol Morris, Steve Freeman, Bruce McCall, Persi Diaconis, Sam Messer, Tim Felix, Ren Weschler, Art Spiegelman, Gary Shafner, Bill Kalush and his progeny Alexander, Mark Singer, Daniel Samson, Peter Brauning, David Simone, Michael Zinman, and my publisher and pathfinder, Eli Horowitz. May I single out further, for assistance and guidance beyond the call of duty or friendship: Coco Shinomiya, Susan Green, Stan Coleman, Winston Simone, Michael Weber, and Chrisann Verges.

ABOUT THE AUTHOR

Acknowledged as one of the world's great sleight-of-hand artists, Ricky Jay has received accolades as a performer, actor, and author. His heralded one-man shows *Ricky Jay & His 52 Assistants*; *Ricky Jay: On the Stem*; and *Ricky Jay: A Rogue's Gallery* were all directed by David Mamet. As an actor Mr. Jay has been seen in many films, including *House of Games*, *Things Change*, *Heist*, *Red Belt*, *Boogie Nights*, *Magnolia*, *Last Days*, *The Prestige*, *The Great Buck Howard*, and *Tomorrow Never Dies*. He appeared regularly in the television series *Deadwood*, *The Unit*, and *Flash Forward* and has written and hosted his own specials for CBS, HBO, A&E, and the BBC. His consulting company, Deceptive Practices (with partner Michael Weber), has supplied "Arcane Knowledge on a Need to Know Basis" for theater, television, and more than a score of films, including *Forrest Gump*, *The Illusionist*, and *Oceans 13*. He is the former curator of the Mulholland Library of Conjuring and the Allied Arts and has defined the terms of his profession for the *Encyclopedia Britannica* and the *Cambridge Guide to American Theater*. More information is available at rickyjay.com.